TURNER
IN SCOTLAND

Copyright © 1982 by the authors Francina Irwin, Andrew Wilton,
Gerald Finley, Tom Wigley and Nigel Huckstep
Published by Aberdeen Art Gallery
Designed by Pauline Key
Phototypeset in Apollo
Printed and bound in Great Britain
by Balding + Mansell Limited, London and Wisbech

Aberdeen Art Gallery and Museum
 Turner in Scotland.
 1. Turner, J.M.W. 2. Scotland in art
 I. Title
 759.2 ND497.T8

 ISBN 0 900017 09 0

Contents

4 Preface

5 Acknowledgements

6 List of Lenders and Abbreviations

7 Turner the Tourist *Francina Irwin*

11 Turner in Scotland: the Early Tours
Andrew Wilton

21 Images of Time: Turner, Scott and Scotland
Gerald Finley

26 An account of weather conditions during Turner's
tour of Scotland in July-August, 1801
Tom Wigley and Nigel Huckstep

28 The Catalogue

28 Map of 1797 and 1801 tours

43 Map showing Turner's visits in 1818 and 1822

50 Map of 1831 tour

63 Select Bibliography

Preface

A number of years have now elapsed since Councillor Frank Magee, then Chairman of this Committee first proposed that Aberdeen Art Gallery should arrange an exhibition of works by J.M.W. Turner.

Considerable research was required to prepare a case for such an exhibition which would be acceptable to the many owners who were to be approached. Thus *Turner in Scotland* came into being: an attempt for the first time ever to provide a comprehensive survey of Turner's six tours in Scotland between 1797 and 1834.

We have received from all quarters enormous support for this project; our Keeper of Fine Art, Francina Irwin together with Gordon Robertson, Keeper of Exhibition Services, Hugh Rowson, Education Officer, and a number of other members of staff have brought together an exciting and unique exhibition which will shed new light on J.M.W. Turner's visits to Scotland.

As Convener of the Art Gallery and Museums Committee I would like to thank all those involved in the organisation of this exhibition, in particular those many lenders who have been deprived of the pleasure of having their works for the period of the exhibition. I know that many thousands of visitors to the exhibition will greatly appreciate their generosity.

Councillor George A. Whyte
Convener
Art Gallery and Museums Committee
City of Aberdeen District Council

Acknowledgements

Our especial thanks are due to Mr Andrew Wilton of the British Museum Print Room, who has given his advice from the inception of the exhibition. Professor Gerald Finley of Queen's University, Ontario, has most kindly given his time to discussing the plans on his visits to the United Kingdom and we are very grateful for his help. We would like especially to thank Mr Evelyn Joll of Thomas Agnew & Sons Ltd, who has made contact with a number of private owners on our behalf; similarly our thanks are due to Christie's and Mr Charles Leggatt who also traced a painting in a private collection. We would also like to thank the following who have helped with information: Dr Roy Bridges; Mr G.J. Cassidy of the Glasgow Museum of Transport; Mr G.R. Curtis for his information on roads in the Highlands; Dr John Duthie, who helped over the identification of Aberdeen harbour in the *Inverness* sketchbook; Mr Peter Fairweather, Factor, Argyll Estates; Mr Arthur Munro Ferguson; Mrs Ann Forsdyke; Richard Green of York City Art Gallery; Professor Francis Haskell; Dr David Irwin, who acted as chauffeur on a tour of the West of Scotland and backed the project in every way possible; Professor Michael Kitson; James MacIntyre, Hon. Curator of Dunblane Cathedral Museum; Robert McClellan whose knowledge of the Clyde was invaluable in pin-pointing some of Turner's coastal sketches; Mrs Barbara Trengove for drawing the maps; Dr Selby Whittingham; Mr F.B. Whyte; Mr Reginald Williams; the staff of the Department of Geography and the Map Room, University of Aberdeen and the staff of Aberdeen University Library.

Mrs Jill Bridges, who has looked after the secretarial side of the exhibition and whose research into roads and travel in Scotland is incorporated in 'Turner the Tourist', deserves an especial vote of thanks.

An exhibition of this dimension could only be possible with generous financial support from the Scottish Arts Council, the Paul Mellon Centre for Studies in British Art, London, Shell UK Exploration and Production.
We would like to thank all the private owners and the Museums and Galleries who have so generously lent their works to make the exhibition a success.

Ian McKenzie Smith, Director

List of Lenders

Aberdeen Art Gallery and Museums, 64, 103
Aberdeen University Library, 8, 62, 94
Ashmolean Museum, 1, 13, 29, 34, 93
Boston Public Library, 100
British Museum, 2, 3, 6, 9, 10, 11, 12, 14, 15, 16, 18, 20, 21, 22, 24, 25, 26, 27, 28, 32, 33, 43, 49, 50, 51, 52, 53, 54, 55, 56, 57, 58, 71, 76
Dunblane Cathedral Museum, 30
Arthur Munro Ferguson, 101, 102
Glasgow Museum and Art Gallery, 72
Graves Art Gallery, 5
Indianapolis Museum of Art, 45, 46, 74
Lady Lever Art Gallery, 47
Manchester City Art Gallery, 17
Mitchell Library, Glasgow, 95
Museum of Transport, Glasgow, 96, 97, 98, 99
National Gallery of Ireland, 4
National Gallery of Scotland, 85, 86, 87, 88, 89, 90
National Library of Scotland, 48, 78, 79, 80, 81, 82, 83, 84, 91, 92
Plymouth City Museum and Art Gallery, 19
Rhode Island School of Design, Museum of Art, 73
Royal Academy of Arts, London, 35, 36, 37, 38, 39, 40, 41, 42
Tate Gallery, 59, 69
Walker Art Gallery, 7, 31
Yale Center for British Art, 23, 44

Anonymous private collections, 60, 61, 63, 65, 66, 67, 68, 70, 75, 77

Abbreviations

Farington: Joseph Farington, 1801 Scottish tour in his *Diary*, vol.v, August 1801-March 1803, ed. Kenneth Garlick and Angus Macintyre, New Haven and London, 1979.

Rawlinson: W.G. Rawlinson, *The Engraved Work of J.M.W. Turner, R.A.*, 2 vols, London, 1908–13.

TB: Turner Bequest, British Museum.

Wilton: *The Life and Work of J.M.W. Turner*, London, 1979.

Dimensions in the catalogue are given in millimetres; height precedes width.

Turner the Tourist

Turner's career was punctuated by six visits to Scotland. About ten oil paintings, close on a hundred watercolours, some twenty-five sketchbooks, in addition to numerous drawings and prints record his impressions. By bringing together some of these paintings, drawings and prints made on these trips, it is hoped to enable the gallery visitor to assess the impact of the Scottish scene on his development as an artist with enjoyment.

Turner's first introduction to Scotland was a brief excursion over the Border in 1797 when he sketched four abbeys: Kelso, Melrose, Dryburgh and Jedburgh, (*North of England* sketchbook, TB XXXIV). In 1801 he returned for a longer tour and the items relating to it have been catalogued here in order of his geographical progression. He used five sketchbooks on this tour of which the *Edinburgh* sketchbook is on display (No.3). As he travelled north to Edinburgh, where he spent perhaps a week, he sketched at Dunbar and Tantallon castles, with views of the Bass Rock.

The *Scotch Lakes* sketchbook bears an inscription in Turner's hand which dates his tour in the west of Scotland in 1801: '18 of July left Edinburgh and on the 5 of August finish'd this Book at Gretna Green.' Turner's friend, the diarist and topographical painter Joseph Farington, who had already twice visited Scotland and with whom Turner had consulted before leaving London, arrived only five weeks after Turner's departure from Scotland. Farington's detailed diary helps to supplement Turner's pictorial record and underlines the popularity of this tourist route which Farington largely followed in reverse order. (Farington did not go to Tummel Bridge, nor further north than Blair Atholl.) Turner was not in any sense trail blazing; the Gothic Revival castle and recently laid out town of Inverary in particular, were already noted tourist attractions.

The Climatic Research Unit of the University of East Anglia have worked out a detailed report of the prevailing weather conditions during this important visit to the West of Scotland (see p.26). This should help to explain Turner's reactions to the locations he visited, as inevitably the weather conditions determined his treatment of the various sites.

By 1801 the traveller from London to Edinburgh could travel comparatively fast and in reasonable certainty of arriving when scheduled. If he could afford it, and rode as one of the four passengers on a Palmer mail coach, the journey to Edinburgh took only sixty hours. The mail coach network had been made possible not only by the improvements in design and materials used in coach building but also by the building of the turnpike roads. Some three hundred and fifty Turnpike Acts had been passed to set up Trusts in Scotland since 1750, but they covered mainly the south and the east coast of the country. Beyond the invisible line connecting Glasgow, Stirling and Edinburgh was considered to be the Highlands, a poor, undeveloped area suffering from a bad, out-dated and worn-out road system. Once into the Highlands, speeds of 8–13 mph were no longer possible. Farington normally travelled twenty to twenty-five miles a day on his Scottish tour, but once or twice he actually managed thirty as he came closer to the main cities.

Regular coach runs were established from Edinburgh and Glasgow to points radiating like fan ribs, sometimes using the ill-maintained former military roads such as that from Luss to Inverary. But travel across the Highlands, east to west or vice versa was more difficult. As Farington reports, the traveller without his own means of transport had to hire a

chaise or horse in Edinburgh to take him across the central Highlands: local landlords had given up hiring out horses, gigs etc. because they lost money providing the service. This is supported by reports from the Postal Commissioners on services in the area. It seems very likely that Turner in fact hired a chaise for his Scottish tour as he had no close friends in Scotland to provide one for use in 1801. His route was the standard tourist track followed by many other visitors, including the Wordsworths, who found the hostelries unsatisfactory if not downright bad.

His route through the Highlands may easily be followed by a modern traveller: the constraints of physical geography mean that both old and new roads take the same tracks. Of course there are variations of detail caused for example by realignment work but in only three cases are there significant differences between his routes in 1801 and the modern road.

First, the road from Cladich to Dalmally was a former military road so inevitably it went over the top of the steep hill, past a monument from where travellers had splendid views of Kilchurn Castle, Cruachan and Loch Awe while the horses had an essential rest. Farington described the road as 'very difficult'. The road is still there, but little used.

The road beside loch Tay for wheeled traffic was on the south side of the Loch. The modern road for heavy traffic is on the north side and the other is now a minor road used by local people.

Thirdly, it is likely that Turner travelled from Tummel Bridge to Blair Atholl using the former military road north to Dalnarcardoch and then turned south-east on another military road to Blair Atholl. Few car drivers today would choose this road, although the views from the hill-tops are impressive.

1801 was a crucial year for Scottish roads particularly those of the Highlands. In the autumn, Telford was appointed by Parliament to survey the Highland road system and suggest improvements. By 1803 he had reported his findings and the Joint Parliamentary Commissions were set up for Highland Roads and Bridges and the building of the Caledonian Canal. Their work dramatically changed the country: by 1822, 920 miles of roads, 1,117 bridges, harbours, ferry piers and the Caledonian Canal had been built. The Highlands now had a communications network designed for the civilian work of living and trading. Thus when Turner returned to the Highlands in 1831 he would have found his journeying quicker and more comfortable in every way.

Turner's 1801 route can be followed in the *Tummel Bridge* and *Scotch Lakes* sketchbooks. After leaving Edinburgh, he went first to Linlithgow which inspired one of the few oil paintings to result from this tour (No.7). Then on to Glasgow and down the Clyde to Dumbarton from where he proceeded to Luss (by Loch Lomond), Arrochar (at the head of Loch Long), through Glencroe and down to Inverary. Crossing to Loch Awe he made numerous sketches of Kilchurn Castle in its dramatic islanded setting, for which a boat was the recommended means of viewing (No.19). He went via Tyndrum to Killin on Loch Tay (No.20) following its length to Kenmore. He explored Glen Lyon and turned north to Tummel Bridge, a site that inspired both an oil painting and several drawings (Nos.21–3). He visited·Balir Atholl and went through the Pass of Killiecrankie, pausing to draw the immense Ben Vrachie on his way to Dunkeld (Nos.26–7). En route for Dunblane, where he drew the cathedral (Nos.29–30), he made sketches of the vale of Earne. Many views of Stirling and the castle were taken before he travelled south to Hamilton from where he visited the Falls of Clyde, a site which inspired several drawings and a watercolour of Cora Linn (No.31), considered to be the finest of the three falls in the already extensive tourist literature.

Twelve of the sixty large drawings made by Turner during and after this visit have been lent for this exhibition. Known as the 'Scottish Pencils' they have been unfairly denigrated by writers on Turner in the past, although Ruskin realised their importance. Pencil is the ideal medium for conveying the landscape of the west of Scotland. Farington described how at sunset 'the most distant mountains lost all local colour being neutralised by the vapours on which the sun acted: some parts were of a cool grey, others warm grey.' A light rain or mist has a similar effect of bringing out the tonal qualities of the landscape. (The 'Scottish Pencils' are discussed more fully, see No.10.)

In the autumn of 1818 Turner spent two weeks in and around Edinburgh working on the illustrations for Sir Walter Scott's *Provincial Antiquities and Picturesque Scenery of Scotland*. He returned in 1822 on a visit planned to coincide with George IV's state visit to Scotland. In addition to sketching ideas for a Royal Progress (for a full discussion see G. Finley, *Turner and George the Fourth in Edinburgh, 1822*, London, 1981), Turner worked on designs for the title page vignettes for the *Provincial Antiquities*. 'Edinburgh Castle, March of the Highlanders' (No.59) painted c.1835, records one of the colourful ceremonies, the laying of the foundation of the National Monument.

The visit of 1831 was altogether more extensive, taking in the Border country near Abbotsford and reaching as far north as Skye and westwards to Staffa. Turner filled some ten or eleven sketchbooks during this two month visit. It has not been possible to borrow the oil painting, 'Staffa, Fingal's Cave', Yale Center for British Art, owing to its delicate condition. However, the exquisite vignette of 'Fingal's Cave, Staffa' has been generously lent by a private owner by way of compensation (No.75).

The *Stirling and the West* sketchbook (No. 71) is open at a series of successive drawings of coastlines including the Isle of Arran seen from the deck of a steamer.

It can hardly be a coincidence that the third edition of *The Steam-Boat Companion or Stranger's Guide to the Western Isles and Highlands of Scotland* appeared in 1831, together with a sheet map of Scotland and one of the 'Frith of Clyde and the Western Highlands, on a large scale, comprehending the steam-boat routes, neatly done up on cloth, in a case for the pocket.' It seems more than probable that the *Companion* and maps were amongst those that Cadell found Turner consulting when he visited him in London on 13 June 1831 and reported him as being 'all ready with maps and road books'. (Quoted by G. Finley, *Landscapes of Memory*, London, 1980, p.87.) Turner himself is mentioned in this edition of the *Companion* (p.98) in connection with the Loch Lomond steam-boat tour in the description of the head of the loch: 'the ever changing forms and grouping of the mountain scenery, must delight everyone who has ever taken pleasure in gazing upon the production of a Salvator Rosa, or on those of our own English Turner.'

A drawing in the *Stirling and the West* sketchbook of 'Inversnaith' (Inversnaid) which includes a steam vessel, suggests that Turner perhaps took the one day steamer trip from Glasgow to the head of Loch Lomond, offered as Tour number VI in the *Companion*. Alternatively he had the option of taking in both Loch Lomond and the Trossachs in a round trip. Ponies were available at Inversnaid to carry tourists the five miles to Loch Katrine where boats waited to take them on to the Trossachs (*Companion*, p.98). Turner, however, did not like riding ponies because of 'my bad horsemanship', as he told Scott in a letter in 1831 (J. Gage, *Collected Correspondence of Turner*, Oxford, 1980, No.169). Tourists could then return to Glasgow, Stirling or Edinburgh by road.

A study of the *Companion* in connection with the sketchbooks used by Turner in the west of Scotland, suggests that he made full use of the new steam-boat routes, thus cutting down travelling time considerably.

By 1831 the *Companion* reveals a close network of steamboats connecting up the Western Highlands and Islands. The third edition made the claim that:

the stranger can now explore its [Scotland's] mountains, islands, lakes and valleys, with the greatest facility and expedition; and a journey which one hundred years ago, would have been considered the business of a week, and the boast of a life, may now be performed in the course of a day.

It seems probable that Turner took advantage of the facilities available and may have gone on at least five of these tours. For instance the *Stirling and the West* sketchbook shows that he visited Islay where he made drawings of Bowmore and Port Askaig. This was a regular tour from Glasgow via East Tarbet.

The view of Arran with Toward lighthouse in the foreground points to his having taken the trip from Glasgow to Inverary via the Kyles of Bute. He then seems to have connected up with another tour and travelled overland to Oban from Inverary via Dalmally. This would have taken him past Kilchurn Castle again, which he had last seen and sketched thirty years earlier. It seems possible therefore that the 'Loch Awe with a Rainbow' dates from this visit (No.63).

From Oban Turner would have been able to take a further tour to Staffa and Iona. From Fort William a tour to Skye was offered. In addition, the traveller could take the trip up the Caledonian Canal by Fort Augustus and Loch Ness to Inverness, the nearest town to Turner's patron H. A. J. Munro's county-seat Novar at Evanton. The sights that could be viewed from the deck on all these tours are detailed in the *Companion* which makes fascinating reading.

Turner intended to visit Aberdeen to make drawings of sites associated with Byron's early life for *The Works of Lord Byron: with his Letters and Journals, and his Life* by Thomas Moore (1832–36). However in the end no Aberdeen views were used as illustrations.

It has been possible to identify a view of Aberdeen harbour in the *Inverness* sketchbook (No.76) by comparing it with an almost contemporary print. Turner also sketched Stonehaven with Dunnottar Castle perched in its striking position on a headland. A thumbnail sketch of an open crown spire may be the crown of King's College Chapel done in passing from a carriage.

The main object of the 1831 tour was to make drawings for the *Poetical Works* of Sir Walter Scott. Several of the finished watercolours made for the engravers are on display, includ-ing Aberdeen Art Gallery's own recently acquired 'Caerlaverock Castle' (No.64).

In 1834 Turner was back again in Scotland in connection with his illustrations for Cadell's edition of Scott's *Prose Works*. He visited Edinburgh and its environs and it was on this occasion that he sat next to Sir David Brewster at a banquet held in honour of Lord Gray. Brewster was noted for his experimental work in optics and polarised light and was the inventor of the Kaleidoscope. (For a discussion see John Gage, *Colour in Turner: Poetry and Truth*, London, 1969, pp.122–3).

On this last visit to Scotland, Turner returned to Lanarkshire and saw the Falls of Clyde once again. His late oil painting, 'The Falls of the Clyde' (Lady Lever Art Gallery, Port Sunlight), was too frail to make the journey north for this exhibition. Could it have been lent it would have shown Turner's approach to the Scottish landscape coming full circle; starting with the watercolour of Cora Linn (No.31) still in the eighteenth-century idiom, with its subdued tones and ordered structure, to this splendid shimmering oil in which the rocky mass is dissolved by the effects of sunlight on the spray from the Falls.

Francina Irwin

Turner in Scotland: The Early Tours

Turner visited Scotland twice in the early part of his career: once, briefly, in the course of a tour of the north east of England in 1797 and once, on a longer journey, in 1801. These were the years of his first professional success, which culminated in his election as Associate Member of the Royal Academy in 1799, and as full Royal Academician in 1802. They were also the years in which he completed the self-imposed task, begun a decade earlier, of exploring England, Wales and Scotland as thoroughly as possible. The gradual extension of his journeys throughout the 1790s from the south east to the west, the midlands and the north has a logic and a method that bespeaks an extraordinarily self-conscious and disciplined approach to the practicalities of his profession. The final British tour, to Scotland, provided a fitting climax, and, as has frequently been observed, led on with satisfying inevitability to the visit to Switzerland of 1802.

That first journey abroad is generally taken as an epoch in Turner's development, marking the start of his maturity. The Scottish tour of 1801 has consequently been somewhat overshadowed, and the drawings produced in connection with it have attracted relatively little attention. Few of Turner's works, indeed, have enjoyed less spontaneous admiration. Of the most important group, Ruskin commented that 'They are all remarkable for what artists call "breadth" of effect (carried even to dulness . . .)';[1] and Finberg observed in connection with them that 'poetry can be so feeble, so smug and genteel, that we sigh for prose.'[2] Both men spoke of them as 'scientific' in a deprecatory sense; but in doing so also hinted at the truth, which is that the work of this Scottish journey is experimental, transitional, and consequently of exceptional interest in the context of his

development as an artist, and particularly as leading up to the work done in Switzerland a year later.

In order to understand how Turner's mind was expanding at this time we must begin by looking at his practice before 1801. The north of England tour of 1797 illustrates it as well as any. For that journey, which occupied him probably from late June until early September, he used two books for sketching; both of them rather large, and heavily calf-bound with stout brass clasps.[3] The drawings themselves are such as to have been quite understandably used as 'samples' for potential buyers of finished watercolours. They are usually elaborated, detailed pencil studies in which a mass of information is recorded; sometimes they are worked up, wholly or partially, in watercolour. Although occasional pages have only the most rapid sketches, the impression given by these books is one of immense care and diligence, as well as of great beauty. They were working sketchbooks, but they were also specimen books for clients: a dual function which is reflected in the ambiguous nature of the drawings themselves. The spontaneity of the study on the spot coexists here with the order and harmony of the incipient work of art. It is an ambiguity that flavours Turner's sketches and studies throughout his career, and one that has occasioned much misunderstanding of his intentions, nowhere more conspicuously than in the Scottish drawings of 1801.

Turner did not, of course, always work as straightforwardly as he did on the 1797 tour, with two large books of fine 'presentation' studies. He often took smaller books in which he made slighter sketches, as in the case of the Welsh tours of 1795 and 1798. These smaller studies are, however, by no means always or necessarily more 'spontaneous' than

the larger ones. They sometimes represent an intermediate stage in the process of rendering nature into art; for instance, it was in such small books that Turner seems to have developed the idea of the broad preparatory colour study that was to become so important in his working practice. Again, the sketches made in Scotland in 1801 throw unexpected light on this question.

When he slipped across the border in the course of his tour of 1797, Turner travelled from Berwick to Kelso, Melrose, Dryburgh and Jedburgh—the most important of the monastic remains in south-east Scotland.[4] He took them in, as it were, as an extension of his survey of the ecclesiastical ruins of Yorkshire and Durham. No doubt these glimpses of the border country whetted his appetite, as has been suggested,[5] for a more thorough exploration of Scotland; but they were part of a different scheme, and belonged firmly to a different phase in Turner's programme. Between them and the 1801 tour intervened the two visits to north Wales of 1798 and 1799, which gave him the opportunity to refine both his topographical skills and his response to the heightened atmosphere of the increasingly fashionable mountain scenery of Britain.

There are, then, many reasons why admirers of Turner like Ruskin and Finberg should have expected remarkable things from the 1801 Scottish tour, and their disappointment in the results is perhaps understandable; but they have been betrayed into a failure of observation by the wholly unexpected quality of those results: the very fact that what emerged was not like previous works, which should have alerted them to the importance of the material, had the opposite effect. In addition to the 'dulness' imputed to the drawings by Ruskin and the 'smugness' perceived in them by Finberg, it has even been suggested that their 'vapidity' is due to Turner's having been unwell.[6] I intend to show that I have good reason to disagree with these judgements; but it must be admitted that Turner was certainly suffering from some disease or malaise that summer. His colleague at the Academy, Joseph Farington, mentions in his diary for 10 June that 'Turner complained of being weak and languid',[7] and on the twentieth that he 'complained of imbecility',[8] on which account Farington advised him to postpone his

journey to Scotland. This 'imbecility' was no doubt a physical condition, but the common modern meaning of the word, connoting a mental state, was current at that time and Turner's use of it prompts the thought that, while he himself was far from being 'weak in the head', his mother was this year going through one of the crises of her insanity: she was discharged from Bethlehem Hospital in 1801 and placed in a private asylum. This must have had its due effect on Turner, and might explain his state of health. The circumstance also lends a personal dimension to the work he produced in Scotland, which is notable for its sombre and brooding seriousness—the quality that has been misinterpreted as dullness and vapidity.

The tour was planned to start on 20 June, and Farington promised to send 'directions to particular picturesque places'—he had toured Scotland in 1788 and must have given Turner a good deal of advice as to what to see. Turner was to travel in company with a Mr Smith of Gower Street; but nothing is known of this gentleman, though Turner apparently had connections in Gower Street—one of his patrons was the Rev. Mr Lancaster of No.45.[9] Whether in the event Mr Smith went with him is not recorded; however, he probably set out towards the end of June, and must have been away for nearly two months, as opposed to the three originally planned. On the evidence of the sketchbooks Finberg suggested that Turner's itinerary took him by coach to York, then to Scarborough and up to Durham, Newcastle and Berwick. Following the coast through Dunbar he reached Edinburgh, where he probably spent a week or so, making drawings in and around the city. He then set off on an exploration of the Highlands which took him to Linlithgow, Glasgow, Dumbarton, Inverary, Dalmally, Tyndrum, Loch Tay, Tummel Bridge, Blair Atholl, Dunkeld, Sterling, Lanark, Moffat and Gretna. The sketchbook that principally records this peregrination is triumphantly inscribed: '18 of July left Edinburgh and on the 5 of August finish'd this book at Gretna Green'.[10] He was perhaps rather proud of having covered so much ground in the time, for he did not usually register dates so precisely.

Whatever the timetable he envisaged for the journey, he set off well armed with sketchbooks. He seems to have had

eight of them to hand, mostly pocket-sized; but one was a substantial book measuring some sixteen inches by ten. It already contained drawings made during the two previous years, and on account of these is known as the *Smaller Fonthill* sketchbook.[11] It may have been intended to serve as the 'sample-book' for the tour, but was not used in that way. It became instead a collection of broad, rather loose sketches which only rarely employ colour, and then hardly ever with the splendid conviction of the coloured drawings in the sketchbooks of the late 1790s. One exception is the fully coloured view of 'Edinburgh, from Duddingston' which, in common with most sheets in the book, left the artist's studio at an early date (No.4). As a fully worked-up colour study it ranks, not so much with the other drawings in the book, but with the smaller group of watercolour studies that Turner made of Scottish scenes, presumably after returning to London (Nos.9, 15, 16). This handful of views on Loch Fyne and Loch Long have now faded to ethereal, pearly tones which make it difficult to assess their original appearance; but they were evidently painted in strong, vibrant colours typical of Turner at the time. Apart from this group, the more elaborate drawings resulting from the Scottish journey were to take a very different form.

The remaining seven sketchbooks, though small in size, were used for varying purposes, and fall into two functional types. Some were worked through systematically as Turner travelled, affording us some idea of his route. These are the *Helmsley* sketchbook, the *Dunbar* sketchbook, the *Edinburgh* sketchbook (No.3), and the *Scotch Lakes* sketchbook.[12] Of these the *Dunbar* book has some of the characteristics of the second type, which are books that seem to have been used for what we may call 'thematic' purposes. The *Guisborough Shore* sketchbook[13] contains only rough studies of coast scenes, rocks, waves and fishing-boats. The *Tummel Bridge* sketchbook[14] is perhaps partly a route record, but seems to have a more complex function, as we shall discover. The *Scotch Figures* sketchbook[15] was evidently intended to be a compilation of figure studies made on the journey: Turner, with his customary method, set out to provide himself with his own reference book of 'staffage', which anticipates the pattern-books of figures suitable for inclusion in landscapes

that were to become popular in the next decade or so.[16] The systematic and lively recording of the Scottish peasantry, men, women and children, breaks down after seventeen pages, however, and most of the book is empty. Nevertheless Turner was to try the same idea again when he travelled to Switzerland the following year.[17]

About half the studies in the *Scotch Figures* sketchbook are in colour; elsewhere, as in the *Smaller Fonthill* sketchbook, colour makes only an intermittent appearance. There is a notable group of broadly washed distant views of Edinburgh in the *Edinburgh* sketchbook (No.3), which show Turner enjoying the grand simplified masses in which the huddled buildings and hills of the city can be rendered. When making these distillations of simple forms from the complexity of the metropolis he no doubt recalled what Farington must have told him of the classic monumentality of Edinburgh seen from a distance. On his visit there in 1788 Farington had been struck by it as 'an assemblage of objects of a truly classical character' which 'could with! additions have graced the sublime backgrounds of Niccolo Poussin . . .' From one and a half miles away along the Corstorphine road, the city was 'a scene of the Ideal Kind and of the Poussin character'.[18] Turner's two large finished watercolour views of Edinburgh, one from the Water of Leith, the other from Calton Hill (No.6), which he showed at the Academy in 1802 and 1804,[19] testify to his sense of the grandeur of the capital, and combine with innovative candour the smoky atmosphere, the toiling citizens and the bold forms of the rocks in an impressive tribute both to the Athens of the North and to Auld Reekie.

The most explicitly Poussinesque of all the works to emanate from the 1801 tour, however, is not a view of Edinburgh, but an unfinished watercolour of Inverary.[20] This very large drawing was begun considerably later than the others, for its paper is watermarked 1808; only two other Scottish subjects derived from the 1801 tour have later dates. The composition of the 'Inverary' is similar to that of the small watercolour engraved for Mawman's *Excursion to the Highlands and the English Lakes* in 1805 (No.17); but in scale and mood it is altogether grander than that work. It derives some of its power undoubtedly from the fact that it was

abandoned after the principal masses had been brushed in, so that it is in effect nothing more than a bold and simple 'colour structure', the bare bones of the final work. Even more than in the Edinburgh views, buildings play a dominant part, and give the design a structural clarity and force which anticipates Turner's mature masterpiece in the genre of large town views, the view of 'Grenoble Bridge' of 1824.[21]

The other exhibition pieces with Scottish subjects are very different in character, though they are equally large in size and ambitious in conception. 'The Fall of the Clyde, Lanarkshire: Noon' (No.31) which appeared in the 1802 Academy exhibition, is, one may say, a work that complements the view of Edinburgh shown in the same year. While one presents Edinburgh as a Poussinesque landscape with a strong architectural element, the other transforms the Scottish waterfall into an equally classical vision of nature presided over by naiads, which replace the humble staffage of the city view. In both cases there is an evident intention to give topography a new twist—to announce the identity of purpose behind topography and ideal landscape. This was a bold gesture, and one which Turner had been working towards throughout the preceding decade. On several occasions he had virtually arrived at this point, notably in his brooding, Piranesian view of the interior of Ewenny Priory, of 1797, and in a heroic Claudian account of Caernarvon Castle at sunset, shown at the Royal Academy in 1799.[22] But in neither of those works had he introduced figures of any structural importance—let alone the prominent nude figures of 'The Fall of the Clyde'.

These radically modify the significance of the topographical subject-matter, even though the insertion of nude figures into recognisable landscapes was not new: Francis Wheatley had enlivened a view of the salmon leap on the Liffey at Leixlip similarly in 1783[23]—though there, it is true, the figures can be seen as local girls bathing, while the landscape is reduced to a mere study of waterfall and trees with its specific connotations minimised. More germane to Turner's watercolour was the fact that Julius Caesar Ibbetson was at work at about the same time on a view of Hawthornden into which he introduced a large number of nude female figures.

The picture was called 'The Mermaids' Haunt',[24] evoking a dreamlike, visionary mood rather as Turner does. These are all works in the tradition of landscape which reaches back to Cornelis van Poelenbergh in the early seventeenth century; but Turner is radical in using watercolour instead of oil for his purpose, and in insisting so firmly, as he does in his exhibition title, on the exact place and time of day at which his naiads are depicted.

But it is precisely here that the difficulties of dealing with Turner's Scottish drawings manifest themselves. Not the least insistent of the claims made for the 1801 tour has been that it marks the moment at which he left behind his years of apprenticeship and launched into his own creative universe, wholly free of the trammels of eighteenth-century 'Picturesque' topography and indeed of all forms of literal representation. Farington, as we have seen, told him of 'particular picturesque places', and when Turner reported back to Farington afterwards he was careful to assure him that he thought Scotland 'a more picturesque contry [sic] to study in than Wales.'[25] Farington was a leading exponent of the old school of picturesque topography and so the word was no doubt apt in the circumstances; but, we should not expect the term to be used with a consistent meaning, and it is reasonable to suppose that what Turner really meant here was 'Sublime' rather than 'picturesque'. Actually, 'picturesque' is correct in so far as it includes the Sublime as a category of the pictorially satisfying in nature—an entirely plausible eighteenth-century sense of the term. When Turner went on to observe that 'The lines of the mountain are finer, and the rocks of larger masses'[26] than in Wales, he spoke as a connoisseur of the picturesque even while employing language that implies an appreciation of the Sublime. It may be argued that these very qualities, perceived by Turner in the Scottish landscape, forced him into the Sublime mode since the picturesque was no longer adequate to deal with the subject-matter. However, it seems to me that the essential leap had already been made under the impact of north Welsh scenery in 1798–9, and that what happened in Scotland was a development from this. A crucial difference between the Welsh subjects and these Scottish ones is the reintroduction of the human figure, which is

largely absent from the views in Snowdonia and which, as we have seen, was an object of particular study during the 1801 tour. The classicising elements that we have observed in the finished watercolours of Edinburgh and the Fall of Clyde indicate an attempt on Turner's part to assimilate these subjects into the tradition of high art, which he had not been able to do with the landscape of 'wild Wales'. The presence of figures is symptomatic of this process of 'taming' the Sublime, and the language in which Turner describes the grandeurs of Scotland – 'finer' lines, 'larger masses' – suggests scenery that is more stately and ordered than that of Wales. This helps to explain the controlled, formal quality that commentators have found so difficult to understand in his Scottish work.

In exploring the interrelationship of sublimity, classicism and topography Turner of necessity created pictures which violated traditional canons of pictorial content. This has led, even many years after their execution, to misunderstandings arising out of arbitrary attempts to classify them. One of Turner's early biographers, P.G. Hamerton, singled out a large finished Scottish watercolour as definitive evidence of his 'complete deliverance from topography'[27] and commitment to the pursuit of 'elevated' or Sublime landscape for its own sake. Hamerton proceeded to demonstrate that the watercolour was inaccurate in every material respect. The work he discusses is a view of 'Kilchurn Castle, Loch Awe' which is unfortunately lost, and known to us now only from a large engraving of 1847 by William Miller.[28] This has every appearance of being a faithful reproduction of Turner's design, but it differs significantly from the crude outline sketch with which Hamerton tries to substantiate his argument. Since Hamerton's conclusions have been recently accepted without qualification[29] they should perhaps be examined more closely.

One consequence of the loss of the view of Kilchurn is that its precise identity is uncertain. Hamerton says that it was the large drawing shown at the Royal Academy in 1802 as 'Kilchurn Castle, with the Cruchan Ben mountains, Scotland : noon', which is nowadays thought to be the title of another work.[30] If he has mistaken Turner's intention by confusing the two subjects, then some of Hamerton's argument falls to the ground; but it is possible that Hamerton knew for certain that his drawing was the exhibited one. This would be borne out by the fact that the watercolour now known by that title does not very obviously represent atmospheric conditions typical of noon; but the resting peasants, on the other hand, might indicate that time of day. In connection with this point, we should note Turner's frequent insistence on time of day in his works of this period : he cannot have abandoned all concern for specific accuracy when he takes such particular trouble to identify the effects he wishes us to be aware of. Hamerton, however, concentrates on more concrete points : the shape of the castle itself, or the formation of the land around it. Certainly, to judge from his published sketch there is no resemblance at all between what Turner drew and the architecture of Kilchurn. But the engraving suggests that Turner was not as cavalier with reality as Hamerton would have us believe; and the large number of sketches of the castle that occur in the *Scotch Lakes* sketchbook[31] show that he was, in fact, anxious to record its appearance as fully as possible.

Furthermore, it is unnecessary to argue that the search for an idealised or 'generalised' account of Scottish scenery required the abandonment of characteristic local features. Turner may well have wished to produce an 'elevated' subject on Reynoldsian principles, true to the spirit rather than to the literal facts of the place; but to have relinquished recognisable detail would have been as absurd as for Reynolds to have dispensed with likeness in his portraits.

One of the principal ways in which Turner acknowledged his admiration for Reynolds was in his cultivation, in the late 1790s, of the painting style of that most Reynoldsian of landscape painters, Richard Wilson. Wilson had forged a new language of landscape which enabled him to generalise in precisely the manner Reynolds seemed to demand. Wilson's very use of paint, broad, impasted and deliberately avoiding detail, occurs in most of Turner's oil paintings between 1797 and 1800. But it was not apparently until the Scottish tour of 1801 that he attempted to make drawings in the spirit of Wilson. After his long training in the mountains of Wales, he chose Scotland to make a novel experiment inspired by the great Welsh master.

We have seen that on this tour Turner made very few colour studies, or even detailed pencil studies of the kind that could be displayed to patrons as 'samples' for commissions. Instead, he made a long series of exceptionally elaborate pencil drawings on separate sheets (Nos. 10–12, 14, 20–22, 24–28), most of them larger than could be conveniently carried in the form of a sketchbook, but evidently of a size which, once tried, proved itself congenial: on his Swiss journey of the following year he equipped himself with a book of almost exactly the same dimensions.[32] The sheets on which the Scottish series are drawn consist of white Whatman paper prepared by Turner with a buff-grey washed ground which, he told Farington, was concocted of 'India Ink and Tobacco water'. His use of such a makeshift expedient argues necessity rather than choice. He was in the habit of washing his sketchbook pages with grounds of warm earth colours, but it may be that, planning large-scale studies of specific scenery, he was convinced of the need for the toned ground only after he had come into contact with the landscape he was to draw. The cloudy weather which probably prevailed at the time of the journey may have helped to determine the fundamental tone, but he was obviously struck by its suitability for mountain subjects for he used an even cooler grey in his large Swiss book, on a tour that took place, we are told, in fine hot weather.[33] But in that book he introduced a certain amount of watercolour into his studies; in Scotland he deliberately and consciously dispensed with colour in executing his large finished drawings. They are achieved almost entirely in pencil; hence Ruskin's name for the group, 'Scottish Pencils', by which they are generally known today.

But this is very different pencil-work from that of his drawings hitherto. It is made to accomplish everything that washes of colour would do in his usual method of working; but the monochromatic, leaden tone lends a mood to the whole series that is evidently deliberately sought. The touch of the pencil is varied through a wide range of subtle effects, from finest outline to warm tonal modulations, sometimes approaching the appearance of soft black chalk. In a few sheets Turner has amplified the pencil-work with touches of black chalk, and one drawing[34] is executed entirely in this medium, with extensive use of the stump. Most of the series have bodycolour heightening—'liquid white of his own preparing', Farington tells us;[35] and one or two subjects on smaller sheets of paper incorporate a little yellow pigment, but otherwise colour is entirely absent. Despite these technical restrictions the force and grandeur of the 'Scottish Pencils' are equal to anything achieved by Turner in colour at this date. We are reminded of Farington's well-known comment on another group of monochrome landscape drawings, Wilson's views of Rome for the Earl of Dartmouth, executed in the 1750s, of which he said 'they have all the quality of his pictures except the colour'[36]—and the observation applies with exact aptness to Turner's 'Scottish Pencils'. The weight, the disposition of graded tones of grey and black, the warmth of atmosphere and effect within an apparently austere form, all suggest Wilson, and it is difficult to believe that Turner did not have the Dartmouth series in mind when he created his own set.

Wilson's drawings, which were in chalk on blue paper, were presentation pieces, each beautifully mounted by the artist for his patron. Turner's were not works with such an exalted destiny; though he evidently showed them to his colleagues for Farington reported that they were 'much approved'.[37] This indicates that Turner himself had some sense of their special worth, as he was usually secretive about his working drawings. And that is what they really were. They remained unmounted, with rough, often badly torn edges betraying their life in the artist's studio. Some of them were used, as his sketchbook drawings were, as the foundations for more elaborate finished works—the watercolour view of 'Loch Fyne' of 1815, for instance, from TB LVIII-8; or the study of Tummel Bridge which became the subject of an oil painting (No.23).[38]

But the 'Scottish Pencils' are clearly not 'first thoughts' roughly sketched on the spot and left unfinished; nor are they studies which have been partially worked up later to give patrons an idea of what they might expect. The majority of them have an accomplished grandeur and strength of form that bespeaks the evolved work of art. And many of them can themselves be related to much more rapid studies in the sketchbooks, which seem to be the 'preparatory sketches'

for them. The ambiguity is brought out in attempts by Ruskin and Finberg to describe a sheet from the 'Scottish Pencils' which represents three Scots firs behind which stretches an extensive landscape. Ruskin called this a 'Study of trees',[39] which Finberg understood to mean a 'study from nature'. Finding a slight sketch of the same group of trees in the *Tummel Bridge* sketchbook Finberg concluded that the larger drawing was not executed in front of the motif, but worked up, presumably from memory, with the aid of the sketch. The same seems to have been his opinion of the other 'Scottish Pencils' for which there exist corresponding rough sketches.

The case is, then, apparently, a straightforward one. The 'Scottish Pencils' were elaborated from rough studies on the spot, presumably at Turner's lodgings during the tour. Some were subsequently used as the bases for finished works in other media. But this account presents difficulties. First, sketches for all the 'Scottish Pencils' do not exist; and, as Finberg observes, some of them are clearly themselves sketches made on the spot. Second, the character of the most elaborate subjects in the series does not admit of the possibility that they were drawn almost entirely from memory. No doubt Turner improved the tonal balance and 'keeping' of the drawings at leisure, adding white body-colour and strengthening the pencil with chalk where necessary. But what immediately strikes the viewer when looking at even the most splendidly 'finished' of these works is their astounding completeness and precision in the matter of detail. They are bursting with verisimilitude. Each landscape is perceived as a whole, geographical, social, architectural and botanical, the parts related to each other with the most concrete accuracy and conviction. Never for a moment are we in any doubt that Turner actually saw what he was depicting. That he selected his views, and subtly accommodated detail to pictorial demands, need not con-tradict the argument that these drawings show him in a characteristic mood—one that he frequently expressed throughout his life: the mood of the trained topographer who could penetrate with rare insight into the essence of a place. The rough sketches to which the 'Scottish Pencils' relate simply do not supply enough information to build up

such elaborate statements. It is argued that Turner's eye and memory were of incredible sharpness and retentiveness; but while these drawings are radiant proof of his sharp eye, they do not have the appearance of work done from memory. They can have no validity except as careful records, and the way they are constructed confirms that that is what they are. As Ruskin put it, they are 'scientific in the extreme'.[40]

Let us look more closely at the 'Study of trees' about which Ruskin and Finberg disagreed. The three Scots firs are the principal subject of this sheet, but they are not presented in isolation, as botanical specimens; they are part of a land-scape, which unfolds beyond them in a multitude of clearly perceived details: the three firs are merely the most prominent feature of a much larger view. This completeness is typical of the 'Scottish Pencils' and is what most, perhaps, militates against our accepting them as studies from the motif. The sketch of the same three trees in the *Tummel Bridge* sketchbook[41] seems to clinch the matter: first Turner roughly outlined his idea; then he developed it as an entity, at one remove from nature. Furthermore, we may argue, the disposition of the three trees is itself artificial. William Gilpin, in his *Remarks on Forest Scenery* of 1791, had used a very similar group of three 'ill-shaped' trees to show how individually unpicturesque objects can be grouped with satisfactory pictorial effect.[42] Turner's first sketch shows the trees somewhat separated from one another, but in the final drawing they are brought together to make what Gilpin calls 'a good clump'. But whereas Gilpin's trees are in themselves schematic formulae, Turner's Scots firs are unmistakably of that species and clearly portraits of specific trees. The sketch in the *Tummel Bridge* book, slight as it is, is surprisingly informative as to the shape and growth of each tree; but the final version does not have the appearance of an imaginative 'invention' based on that sketch. Each tree is given an amount of attention that would be inappropriate to a 'generalised' tree; the perverse and often ugly twists of the trunks and branches, the fall of light on textured bark, the springing of boughs and broken stumps, all are studied with the minuteness of the botanical draughtsman. To have invented them would have been to gainsay the very point of choosing such a subject in the first place. Turner evidently

improved the grouping of the trees in the final drawing; but this does not mean that he drew from memory. He composed an 'ideal' design *in the process* of working from nature. The rough sketch is therefore a necessary preliminary stage, not recording essential details for reference at a later date, but clarifying for the artist the basic content of his composition.

In the light of this analysis, the *Tummel Bridge* sketchbook as a whole emerges as a book in which Turner can be seen testing possible designs for his series of finished pencil drawings.

This creative sequence is worth comparing with an instance from the Welsh tour of 1798. In Turner's *North Wales* sketchbook of that year there occur two studies of the same subject,[43] one roughly outlined on an endpaper, the other, more careful and detailed, in the regular sequence of drawings that fills the book. In this case it is plain that he made the detailed drawing first, from the subject, and, at some odd moment later, used the endpaper of the book to reconsider the view in terms of a 'composition', adding a foreground tree (of a very summary kind) and 'improving' the design slightly. When he came to work on the 'Scottish Pencils' three years later, he anticipated this stage by making his rough 'composition' study *first*, so that when he came to draw from nature he was able to fuse great accuracy on to a previously conceived plan. The process is analogous to that advocated by Alexander Cozens in his use of 'blots' and other means of generalising before allowing specific natural detail to intrude into the design.[44] Cozens worked almost entirely in monochrome, and if Turner had his methods in mind that fact may perhaps have helped to influence his choice of medium for the 'Scottish Pencils'. In this, then, he shows himself the heir of a crucial eighteenth-century principle of landscape composition, but one who deploys his inheritance with a quite novel imaginative and creative insight.

It is in the matter of Turner's use of eighteenth-century landscape theories that the watercolour of 'Kilchurn Castle' re-enters the discussion. As we have seen, it has been used to show his emancipation from topography; it has simultaneously illustrated the point that he wished to generalise landscape towards a nobler, more sublime mode. In stressing this, commentators have overlooked the vivid realism which makes the 'Scottish Pencils' so commanding as works of art. One of them ('Scottish Pencil' No.16) is in fact the basis for the watercolour discussed by Hamerton and is itself, as we should expect, a highly-wrought and essentially 'finished' view. The composition sketch for it is not in the *Tummel Bridge* sketchbook, but in the *Scotch Lakes* book,[45] which, as already noted, is concerned not with 'compositions' but with topographical facts. It suggests the possibility that, in this case at least, Turner relied on a preliminary sketch, and so moved further away from what he had originally seen than he would have done if his finished pencil drawing had been made on the spot. But there is no reason to suppose that he did not make *two* drawings on the spot—the first a rough sketch, the second a more considered and highly-wrought drawing. The second, at any rate, conforms in all important respects with the first, which however hardly includes enough information to have been the only source for it. What is particularly noteworthy in this 'Scottish Pencil' drawing is that it satisfies the salient topographical requirements of the subject in precisely those areas in which, according to Hamerton, the finished watercolour fails to do so. Both the shape of the castle and the undercutting of the river banks are observed here, as they seem to be in the engraving, though, if Hamerton is to be believed, Turner allowed himself much licence in these areas when he came to construct his watercolour. Nevertheless, the point to be made here is that, whatever the final statement, Turner's work originates in the recording of exact truth, as Ruskin insisted. The 'Scottish Pencils' show this again and again.

All in all, we are forced to the conclusion that Hamerton's reading of the 'Kilchurn Castle' watercolour is at best only a partial response to Turner's intention in painting it. The 1847 engraving corresponds to a great extent with the 'Scottish Pencil' which treats of the same subject and which, as I have argued, seems a fairly accurate account of the scene. And a comparison of the second Kilchurn watercolour with its related 'Scottish Pencil' drawing[46] shows that in fact Turner's modifications were usually very much in the spirit of the place as he had first drawn it. Mountains may be raised to increase their grandeur, and the scale of a view generally exaggerated for the sake of pictorial drama; but the essential

lines of the landscape, and much of its detail, remain unchanged from pencil drawing to watercolour. There is no betrayal of topographical truth, even when the higher demands of the Sublime are met. A comparison of Turner's view with a painting of the same subject by the Victorian artist Alfred William Hunt[47] shows that, in this instance, he departed hardly at all from what any observant draughtsman might choose to include in a depiction of the scene. Only in the expansive rhythm imposed on the whole design by the overarching rainbow can its special quality of majestic breadth be traced to a deliberately calculated 'effect' on Turner's part.

What is more, Turner's practice for the rest of his life leaves us in no doubt that to speak as Hamerton does of a 'complete deliverance from topography' is to miss the point of much of his art. In a large number of his works, and especially in his watercolours, it was precisely the combination of topographical truth with emotional grandeur that he aimed at. He was happy to distort geography in the interests of art, but he did not as a rule deny the essential character of the place he was depicting. This would have run counter to his early training and most deeply ingrained instincts. His particular tribute to the scenery of Scotland was to forge from it works of art in which this persistent ambiguity found its first mature and fully resolved expression.

Andrew Wilton

Notes

[1] J. Ruskin, *Notes on Pictures*, 1902, p.168.

[2] A.J. Finberg, *The Life of J.M.W. Turner*, 2nd ed., 1961, p.75.

[3] The *North of England* sketchbook (TB XXXIV) and the *Tweed and Lakes* sketchbook (TB XXXV).

[4] See TB XXXIV ff.58–64; XXXV ff.16–18.

[5] G. Finley, *Landscapes of Memory*, 1980, p.23.

[6] J. Lindsay, *J.M.W. Turner, a critical biography*, 1966, p.75.

[7] J. Farington, *Diary*, ed K. Garlick and A. Macintyre, 1978 etc., entry for 10 June 1801.

[8] J. Farington, *Diary*, 20 June 1801.

[9] See Turner's note in the *Hereford Court* sketchbook, TB XXXVIII, f.52. Turner's travelling companion to Scotland in 1801 may have been the Nicholas Smith Esq. listed as living at 42 Gower Street in *Holden's Triennial Directory, 1802, 1803 & 1804* (3rd edition).

[10] TB LVI, inside front cover. A.J. Finberg, *op. cit.*, p.74, sums up the itinerary by saying that Turner 'had "done Scotland" in about three weeks'. This has caused misunderstanding. The Highland journey from Edinburgh to Gretna lasted three weeks, but Turner must have stayed at

least a week in Edinburgh, and he took a few days to reach Edinburgh from Berwick; so that the total time spent in Scotland was probably nearer five weeks. A further week must have been taken up in travelling from London to York and from Gretna to London; and he apparently spent some time in Yorkshire and Durham (drawing at Scarborough, Whitby, Rievaulx, Durham and elsewhere). The whole tour, then, probably lasted for the better part of two months. Details of Turner's expenses on the journey were recorded in TB LIII, inside back cover; they are transcribed by Wilkinson, *op. cit.*, p.113.

[11] TB XLVIII.

[12] TB LIII, LIV, LV, LVI.

[13] TB LII.

[14] TB LVII.

[15] TB LIX.

[16] The best known example and apparently the earliest is W.H. Pyne's *Microcosm: or, a Picturesque Delineation of the Arts, Agriculture, Manufactures, &c. of Great Britain, in a Series of above a thousand groups of Small Figures for the Embellishment of Landscape*, which first appeared in 1803.

[17] In the *Swiss Figures* sketchbook, TB LXXVIII.

[18] J. Farington, 'Journal of a Tour to Scotland', 1788, typescript in the British Museum.

[19] Wilton 347, 348. The view of 'Edinburgh New Town, castle, &c., from the Water of Leith' which was shown in 1802 is now lost, but another watercolour (Wilton 347a) is apparently a (cut down) version or variant of it and probably gives a fair idea of the right-hand two thirds of the design.

[20] TB LX-J.

[21] Wilton 404.

[22] Wilton 227, plate 28; Wilton 254, plate 47.

[23] In the Yale Center for British Art; see M. Webster, *Francis Wheatley*, 1970, No.45, plate 50. The subject was engraved by R. Pollard and F. Jukes, 1785.

[24] See J. Holloway and L. Errington, *The Discovery of Scotland*, 1978, p.80, fig.81, and p.85.

[25] J. Farington, *Diary*, 6 February 1802.

[26] *Ibid.*

[27] P.G. Hamerton, *The Life of J.M.W. Turner, R.A.*, 1879; new ed. 1895, p.65.

[28] Rawlinson 644.

[29] J. Gage, 'Turner and the Picturesque–II', *Burlington Magazine* CVII, February 1965, p.76.

[30] Wilton 344. See No.19.

[31] TB LVI ff.51 verso–64 recto.

[32] The *St. Gothard and Mont Blanc* sketchbook, TB LXXV.

[33] Farington, *Diary*, 1 October 1802.

[34] A view of Taymouth, TB LVIII-43.

[35] Farington, *Diary*, 6 February 1802.

[36] See B. Ford, 'The Dartmouth Collection of Drawings by Richard Wilson', *Burlington Magazine* XC, December 1948, p.337.

[37] Farington, *Diary*, 6 February 1802.

[38] TB LVIII-39; Butlin and Joll B/J 41.

[39] TB LVIII-56, Ruskin *op. cit.* p.168.

[40] *Ibid.*

[41] TB LVII f.1 verso–2 recto.

[42] W. Gilpin, *Remarks on Forest Scenery and Other Woodland Views (Relating Chiefly to Picturesque Beauty)*, 2 vols, 1791, I, opp. p.175. Some of the plates in Gilpin's book are by his brother, Sawrey Gilpin, with whom Turner collaborated on a watercolour in 1799 (Wilton 251).

[43] TB XXXIX, inside front cover and f.20 recto.

[44] See A. Wilton, *The Art of Alexander and John Robert Cozens*, Yale Center for British Art, 1980, pp.31–2.

[45] TB LVI, f.57 verso–58 recto.

[46] TB LVIII-15.

[47] A.W. Hunt, *Sunset over the Loch, Kilchurn*, 1855, sold at Sotheby's, 21 July 1982, lot 149 (repr.).

Images of Time: Turner, Scott and Scotland

Turner and Sir Walter Scott were business associates but never friends.[1] Although they collaborated successfully on two major publications, Scott's *Provincial Antiquities and Picturesque Scenery of Scotland*, which was published between 1819 and 1826, and an edition of Scott's *Poetical Works*, published during 1833–4, they really had little in common. They came from vastly different backgrounds, and cultivated different interests, tastes, and manners of living. Still, for one brief moment in their lives—in 1831—only a year before Scott's death, they discovered qualities in one another which they had not previously recognised. As well, they probably came to realise they shared an interest in Scotland and its traditions, and a similarity of outlook on the past.

Turner had first visited Scotland in 1797, when he was in his early twenties. It was a brief, discursive, almost accidental tour along the Borders. In his sketchbooks, he made a series of rapid pencil notations of architectural ruins and of decorative groupings of buildings and trees. The forms and patterns in these sketches betray his youthful viewpoint which was under the influence of the Picturesque—that connoisseurship of scenery whose unthinking conventions coloured the forms and manners of the drawn and painted views of many late eighteenth and early nineteenth-century artists and topographical draughtsmen. Turner's sketches do not convey the impression that, at this time, he had any special feeling for the character of Scotland.

In 1801, four years later, Turner made his second Scottish visit, when he stayed longer, travelled further, and made more sketches of more varied subjects and terrain. He also studied Scotland's landscape more closely, this time from a viewpoint now liberated to a considerable extent from the conventions of the Picturesque. These studies, though still rapidly sketched, show a more acute observation and sensitivity to the material character and spatial existence of his landscape subjects than do his 1797 Scottish sketches. Consequently, the 1801 landscape sketches appear more impressively probing than do those made earlier, and therefore convey a greater authority. Indeed, on this second visit Turner was so overwhelmed by the scenery of Scotland, especially of the Highlands, which he saw for the first time on this trip, that on his return to London he excitedly declared that the 'lines of the mountains are finer [than those of Wales], and the rocks of larger masses.'[2] This heady enthusiasm informs a number of works which he drew and painted, including a series of large finished pencil drawings, perhaps begun in Scotland, and some watercolours which were completed on his return to London. The finished pencil drawings ('Scottish Pencils', Nos.10–12, 14, 20–22, 24–28) are fresh and decisive, boldly capturing the grandeur, and revealing the remarkably barren spaciousness of the Scottish terrain; in consequence these works present a powerful, sublime immediacy that even the most resolved of his rapid on-the-spot sketches, some of which may have inspired them, can only elusively suggest. (The pencil and watercolour views resulting from this Scottish tour anticipate the spatial grandeur of the Alpine watercolours which were to be the fruits of his 1802 Continental tour.[3])

Turner boldly captured the physical qualities of Scotland's landscape in these finished pencil drawings and watercolours; he also invested them with a remarkable mood. The impressive forms of these landscape views, the spaces which their forms define, the atmospheric environments which envelop these forms, and their richly varied

chiaroscuro effects, together contribute to the emotional strength of Turner's pictorial images. Through them he has conveyed the sensations and associations he experienced as he contemplated this Scottish scenery and sketched it. In several of these finished pencil drawings and watercolours (and in others not of Scottish subjects which were painted before and after this time) Turner selected as subjects sites to which historical associations firmly, or loosely cling, so as to give his landscape drawings or paintings added interest, and to heighten their expressive effect.

Scott and Turner, in their early maturity, had recognised the value of the past in enhancing the expressiveness of their respective arts. During the seventeenth and eighteenth centuries, the aesthetic appreciation of the past had been nurtured by investigations in history and antiquarianism, and also the phenomenon of memory, which had determined that man could refine his awareness of his existence, and his place in time, through the contemplation of the past. Furthermore, by means of memory, man could recognise the interconnections and interrelationships between the past and the present which could illuminate the significance of both. The cult of the Picturesque with which Scott, as well as Turner, was familiar, helped to convert this interest in the past to an aesthetic enjoyment of scenery and art: past events associated with a particular location could give it greater significance by arousing memories or associations invoked by it, thus enhancing the viewer's aesthetic appreciation of it.

This common interest in the past brought Scott and Turner together in 1818: Scott, a knowledgeable, enthusiastic antiquarian and historian; Turner, an eminent illustrator and painter of historically significant landscapes and ancient architecture. Scott had long been collecting materials relating to the history and antiquities of Scotland, and in 1818, decided that this collected information should be published as a book. He did so, and entitled it, *Provincial Antiquities and Picturesque Scenery of Scotland* (see Nos.48–55). This work, as many others of the period, was undertaken as a speculative venture: Scott, his publisher and others engaged on the publication, were shareholders in the project. When Scott asked Turner to illustrate this work (because of Turner's reputation as an illustrator of scenery and ancient architecture), Scott also asked him to become one of its shareholders. That Turner accepted this commission was probably not entirely due to his wish for financial gain; nor for further enhancement of his reputation. Though Turner, as a recognised illustrator, was able to negotiate favourable terms of employment on this project, he did not have the prestige of being its sole illustrator. Nor were the other illustrators with whom he was to be associated, the most eminent. Consequently, one might conclude that Turner accepted this commission because the project was Scott's. Turner had long recognised Scott's reputation, and by this time (1818) had probably read at least some of his works; he certainly knew of them. As both a shareholder and an illustrator, Turner could have considered this collaboration an excellent opportunity to make Scott's acquaintance.

In 1818, Turner made his third visit to Scotland to sketch subjects considered for illustrations for the *Provincial Antiquities*. When he arrived in Edinburgh, he did not make a good impression on his Scottish hosts. The close-knit cultural community of that city had been anxious to meet this famous painter from the south, but when they did, were greatly disappointed: his apparent secrecy (he would apparently allow only Scott to see his sketches) offended them; his cockneyisms, his bad manners (he failed to attend a dinner given in his honour) irritated them; and his apparently condescending manner upset them. Furthermore, Turner had struck a particularly hard bargain when negotiating over the price of his illustrations, which some of the shareholders found distasteful. Scott was one of them; he later confided to a close friend (also a shareholder): 'Turner's palm is as itchy as his fingers are ingenious and he will, take my word for it, do nothing without cash, and any thing for it. He is almost the only man of genius I ever knew who is sordid in these matters.'[4]

By 1822, the year of Turner's fourth Scottish visit, the cloud under which he had earlier left Edinburgh had somewhat dissipated. He came north either on *Provincial Antiquities* business, or his own projects, or perhaps on both of these matters. Whatever the reasons, his major task was to

record an important historical event: the visit of King George IV—the first Hanoverian monarch to set foot on Scottish soil. Sir Walter Scott, made stage manager of the grand welcome, had devised appropriate, elaborate ceremonies and processions for it, which were rich in pageantry, and commensurably, in historical allusion. The traditional symbolism of these ceremonies and processions was intended to illuminate Scotland's present condition. For example, Scott arranged for the King to be ceremonially presented as a hero—as the effective reconciler of the past differences between England and Scotland: one way he achieved this was to have the King don the Royal Stuart tartan so that the King could appear as the living metaphor of the reconciliation of the royal houses of Stuart and Brunswick, and simultaneously, dramatically affirm his legitimate descent from King James VI of Scotland.

Turner was deeply impressed by the splendour of the royal welcome. He may have been encouraged by Scott to come to see these festivities since Scott wished him to prepare special designs for the *Provincial Antiquities* which would commemorate this royal event. The sales of the publication, to this time (1822) had been poor, and Scott probably believed that the inclusion of commemorative designs would encourage sales. Still, it is possible that Turner decided to come to Scotland quite independently of Scott, and that the author's request for commemorative designs was made later.

Turner sketched the royal festivities in and around Edinburgh in one of the two sketchbooks which he carried with him. In the other, he composed minute, elaborate pencil designs for a series of pictures on the theme of the royal visit. What he prepared was an elaborate proposal for a 'Royal Progress' in the tradition of Renaissance and Baroque pictorial triumphs. In so doing, he planned not merely to record the festivities of the visit but, apparently, to reinforce pictorially Scott's ceremonial intention of recovering aspects of Scotland's past, in order to illuminate its present. Only within the elaborate rhetorical framework of traditional pictorial triumphs could Turner decorously represent the King as the heroic instrument of the emotional reconciliation of England and Scotland, which the King's Scottish visit had

made possible. Though Turner never completed this grand series of pictures (there are, I believe, four unfinished oil paintings which can be associated with this cycle), he used its compositions as the basis of several watercolour designs, two of which were employed as the commemorative vignettes for the *Provincial Antiquities* (Nos.56 and 57); unfortunately, their inclusion in this publication did not ensure its financial success.

The association of Scott and Turner on the *Provincial Antiquities* project was intermittent, but it continued until 1826. The publication was issued, beginning in 1819, in ten separate, illustrated numbers, and in 1826 was concluded in a collected work released in two bound volumes. Scott's text and Turner's illustrations share a common viewpoint: the landscape views and architectural monuments described by Scott and depicted by Turner (and, indeed, by the other illustrators) are as these sites appeared to the writer and artist at that time—not as they had in the past. This same viewpoint was adopted by Turner for his second, more important and final, collaboration with Scott in 1831—when Scott and his latter-day publisher, Robert Cadell, commissioned from him a set of designs for a new edition of Scott's *Poetical Works* (Nos.78–84).

In the spring of 1831, after a tentative list of subjects for illustration had been devised, Scott invited Turner to visit Abbotsford, the author's country-house on the Tweed, to sketch locations in the vicinity which were on this list. Turner was delighted to receive Scott's invitation; he relished the thought of visiting Scotland again, and collaborating once more with Scott. When Turner answered Scott's letter, thanking him for his invitation and accepting it, he also informed him, as there were northerly subjects proposed for illustration, that he hoped to travel further than Abbotsford—to go north to 'Staffa Mull and all'. Turner arrived at Abbotsford in early August, where he stayed for almost a week, and, following his proposed plan, travelled first to Edinburgh and then north to the western Highlands and Isles. Almost two months later, he returned to London with a rich harvest of sketches.

Turner had stayed at Abbotsford for only five days, but his itinerary was crowded. In the company sometimes of

Scott (who was seriously ill), and always Robert Cadell, Turner visited sites either associated with the author's life, or described, or alluded to in his poetry. High on the list of preferred local subjects were ancient monuments which included Smailholm Tower, Melrose Abbey, Dryburgh Abbey, and Bemerside Tower. Scott, when sufficiently well, rejoiced in the opportunity to visit some of these beloved sites in the company of Turner and Cadell. On those outings with Scott, the author kept his guests amused by recounting the history and reciting the ballads of the districts they were visiting; the countryside near Abbotsford was resonant with associations: 'every valley has its battle,' Scott had mused, 'and every stream its song.' Scott's absorbing commentaries on the historical and cultural background of these localities, made either on their journeys, or at Abbotsford over dinner and drink, refined Turner's sensitivities to the countryside, investing it with new significance for him, and feeding his growing enthusiasm for the Border scenery. Although Scott was often exhausted by his role as host, he enjoyed the lively company of his two guests; he had always admired Cadell, and had relished his visits, but he was pleasantly surprised to find Turner so attentive, cheerful, co-operative, and thoroughly delighted with the scenery; Turner was not the difficult visitor he had expected to receive. Turner enjoyed Scott's company, too; this visit confirmed, and deepened his admiration of, and respect for, Scott. The two men had the time to become aware of their common interests: their love of Scotland, and of the past. That they spoke of shared interests seems likely; indeed, Turner's watercolour designs for the *Poetical Works* strongly suggest that they did.

Turner did not begin the poetry designs on his return to London in September; it was not until February 1832 that he finished the first of them. At this time, to the surprise of some, Scott was still living in Italy where he had gone in the hope of regaining his former good health; however, he did not recover, and never saw the poetry designs that Turner had prepared. Turner had had a premonition that Scott would never see them, and so created a special watercolour gift which he sent abroad to him (No.65), which depicts one of the poetry design subjects, and is painted in their style. This watercolour shows Smailholm Tower in the back-ground, and in the foreground, the figures of Turner, Scott, and Cadell in Scott's open carriage as they leave the precinct of the tower, and the nearby farm of Sandyknowe. Scott was delighted to receive this gift from Turner, which arrived only a few months before Scott suffered a massive, cerebral attack that mentally incapacitated him, and from which he never recovered; he was brought home to Abbotsford in July, where in September, he died.

Like the gift watercolour, several designs for the volumes of the *Poetical Works* commemorate Turner's 1831 Scottish visit. They are some of the most richly symbolic (it is symbolism which is both explicit and submerged) and captivating views of Scottish scenery that he was to paint. Though these landscapes (and those in the remaining poetry designs) are enriched by their associations with Scott's poetry, their expressiveness is often heightened by the personal allusions which some of them contain, particularly those documenting the Abbotsford visit; they are equally important, however, as a testament of Turner's deeply-felt belief in the value of the past.

Of the designs for the *Poetical Works* which celebrate the passing of time, the most significant is *Bemerside Tower* (No.80). In it, Turner has commemorated his visit to Bemerside with Scott in the summer of 1831, and enriched it with allusions to the brevity of life. Turner has represented Scott, Turner, and Cadell, after their arrival at Bemerside on the afternoon of Saturday 6 August. In the middle ground, under a great tree, Turner shows himself sketching Bemerside; in the foreground, Scott in the light-coloured suit, leans towards Cadell standing next to him; on the other side of Scott is Miss Mary Haig, the Laird of Bemerside's daughter, who greeted the trio on their arrival and guided Scott and Cadell round the property, while Turner made his sketch of the house.

But Turner has falsified his presentation of these events in order to allude to Scott's poor state of health. As the seriousness of Scott's illness was known only to those who were close to Scott, Turner shows Cadell (who knew Scott well, and had probably informed Turner of the gravity of Scott's condition) drawing Scott's attention to an assemblage of potted plants which, in symbolising Scott's passed,

accumulated years, alludes to his mortality.

There is yet another allusion to the passing of time, within which the above, more personal reference to Scott's illness is given further resonance: the sundial, and the spilled crock next to it, refer symbolically to mutability, and the 'sad fleetingness of all things human'; but since a framed, painted portrait of Scott rests against the podium supporting the sundial Turner refers specifically to Scott's mortality. As laurel branches lie on one side of this portrait, Turner alludes here to Scott's literary success and genius, and to the immortality which, after death, his artistic achievement would bestow on him.

A further perspective on this temporal theme is furnished by the volume of Thomas the Rhymer's verse, the thirteenth-century bard, placed on the other side of the framed portrait of Scott. Bemerside Tower had been selected as the subject to illustrate Scott's poem, *Sir Tristrem*, because the poem was an adaptation of the metrical romance by Thomas the Rhymer, and Thomas was believed to have been a frequent guest at Bemerside. Indeed, he was apparently well-enough acquainted with the resident Haig family to have referred to them in the following prophetic couplet: 'Betide, betide, whate'er betide,/There shall be Haigs in Bemerside.' Thus by pictorially placing Thomas's book of rhymes next to Scott's framed portrait Turner has acknowledged the historical, literary source of Scott's poem, and, at the same time, cogently symbolised the continuity of the Scottish literary tradition. In so doing, Turner has further revealed his profound belief in the value of the past as a means of illuminating the present–a point of view that Scott also shared. Had Scott been able to examine this poetry design, he would probably have appreciated the temporal meanings which it holds.

Scott's death did not end Turner's connections with the author's writings. He illustrated further books by, or about Scott, and made a final visit to Scotland in 1834, to sketch some scenes for their illustration; the two most important of these books were published by Cadell: Scott's *Prose Works* (1834–6) (Nos.85–90) and Lockhart's classic *Life of Scott* (1839) (Nos.91–2). Turner's memories of and respect for Scott are reflected in several of their designs, which, like some of those prepared for Scott's *Poetical Works*, are autobiographical, and strongly evoke a past which has relevance for the present. In them, Turner's feelings for Scott are revived and warmed once more, mainly through his vivid recollection of that brief, cherished Abbotsford visit that he had made in the late summer of 1831.

Gerald Finley

[1] The material of this essay has been derived largely, though not entirely, from my recent publications on this subject, notably, *Landscapes of Memory: Turner as Illustrator to Scott*, London, 1980, and, to a lesser extent, *Turner and George IV in Edinburgh, 1822*, Edinburgh, 1981.

[2] A.J. Finberg, *The Life of J.M.W. Turner, R.A.*, 2nd ed., Oxford, 1961, p.76.

[3] G. Finley, 'The Genesis of Turner's ''Landscape Sublime''', *Zeitschrift für Kunstgeschichte*, 42, 1979, p.165.

[4] National Library of Scotland, MS 965, f.62, 30 April 1819, Scott to J. Skene.

An account of weather conditions during Turner's tour of Scotland in July-August 1801

Turner noted in a sketchbook that he had left Edinburgh on 18 July and finished the book at Gretna Green on 5 August. His itinerary was as follows:
Edinburgh—Linlithgow—Glasgow—Dumbarton—Loch Lomond—Arrochar—Glen Croe—Loch Fyne—Inverary—Loch Awe (Kilchurn Castle)—Tyndrum—Killin—Loch Tay—Kenmore—Tummel Bridge—Blair Atholl—Killicrankie—Dunkeld—Vale of Earne—Dunblane—Stirling—Hamilton—Lanark (Falls of Clyde)—Moffat—Gretna Green.
He appears to have spent a longer time at Inverary than elsewhere as he had a commission from the Duke of Argyll and there are numerous studies. As no dates are known apart from the start and finish of the tour, it is not possible to calculate when he would have reached any given location. However by the middle of the nineteen days he must have been well into Argyllshire and Perthshire.

The following account of the weather, reconstructed from historical data for the period, gives a clue to the conditions that Turner encountered on his first visit to the Scottish Highlands.

F.I.

By 1801 the observation of the weather was an established scientific interest and learned societies all over Europe had established networks of observers using standardised instruments. In addition, many private individuals were intensely interested in the weather and kept their own detailed records. In spite of this wide coverage of Europe with meteorological observers, difficulties in communication between the various observers meant that it was not possible to produce synoptic weather charts (the sort of chart which appears in today's newspapers and on the television weather forecast) at the time the observations were made. Weather maps were first drawn in 1820, when H.W. Brandes, a German meteorologist, constructed some charts for the 1780s by compiling old observations. These early charts have, unfortunately, not survived. Production of weather maps of the sort with which we are familiar today did not begin in earnest until the end of the nineteenth century.

It is possible to reconstruct, with a reasonable degree of accuracy, the prevailing weather during Turner's tour of Scotland because the relevant meteorological observations from many parts of Europe have survived. The information these records give about rainfall, temperature, atmospheric pressure and wind-direction for each day are plotted on to a map and these data are then used to produce the atmospheric circulation patterns of that day. When the series of charts is complete, they give a picture of the changes in circulation which were taking place, and from this one can derive an account of the weather for the period under study.

The weather in Europe is determined by the regular progression of cyclones (low pressure areas) moving westward from the Atlantic and by the different air masses which these pressure systems bring with them. The paths or tracks of the cyclones often pass across England and Scotland in the winter, bringing rain and snow. In summer these tracks migrate northward, and the cyclones tend to pass across Iceland to the north of Scotland and into northern Scandinavia. This allows warm anticyclonic air to penetrate

over the United Kingdom from the mid latitudes of the Atlantic Ocean. Sometimes, however, cyclones track further south than normal and when they run across the United Kingdom they bring cool, cloudy and wet weather. This sort of weather is often associated with a high pressure over the North Atlantic or northern Scandinavia which can remain in the same position for many days. This situation, with prolonged similar weather conditions, is called 'blocking'.

In 1801, July was characterised by such conditions. Temperatures in England and Scotland were about normal (i.e. similar to average conditions today), but the month was wetter than normal especially in England. August was also a fairly average month. However, the period around late July–early August was rather more dismal than average and cool, cloudy weather prevailed.

In mid July a low pressure system over the low countries brought northerly winds and cool conditions to most of England and Scotland. The days were cloudy, but not overcast. On 19–22 July a new low moved into the area causing wind direction changes, bringing a little relief from the cool weather, and some reduction in cloud. Cloudy, cool conditions returned as this low moved across to southern Scandinavia. A blocking situation developed around 23 July and the low over southern Scandinavia intensified. A strong, cool northerly air stream prevailed over Scotland. On 24 July, as the normal high pressure area which covers the mid-latitude Atlantic Ocean strengthened, cool, clear conditions prevailed with morning fog in some areas on the 25th. Movement of the low soon brought back cloudy conditions with drizzle on the 26th–although clear (but cool) weather still prevailed over the southern United Kingdom.

On the 27th the weather was dominated by the blocking pressure pattern over northern Scandinavia and the winds turned more easterly as the low over southern Scandinavia moved to the east. As a consequence, the weather over Scotland remained cool to mild and cloudy. A low pressure system moved in over England about this time bringing unsettled conditions in the south. This low intensified over the next few days as it moved slowly eastward. Cloudy unsettled conditions developed with rain over England and Scotland on the 29th. On the 30th the weather was still controlled by the high over Scandinavia with the low over France bringing rain in England. Conditions in Scotland were cloudy and cool with a northeasterly air flow.

The weather deteriorated everywhere on the 31st. A new strong low entered from the west over southern England bringing heavy rain and foggy, drizzly conditions in the north. On 1 August an unstable air stream prevailed over the southern United Kingdom in the wake of the previous low, while the Scandinavian blocking pattern dominated conditions further north. Showers were frequent in the south, but these became less frequent as one moved northwards so that most of Scotland was cool and cloudy. 2 August was similar with wet, miserable weather in the south and cloudy, cool conditions (clearing at night) in the north. The 3rd was similar, but the blocking situation, which had maintained fairly constant weather conditions over previous days, began to disintegrate causing a wind direction change in Scotland bringing cool winds in from the Atlantic. However, the change in winds brought little respite from the cool, cloudy conditions. 4 August was slightly better. Rain ceased in the south, and in the north clear skies appeared in the afternoon. More cyclonic activity began the next day with stronger winds, milder conditions in the south, but it was still cloudy over Scotland.

The prevailing weather during Turner's tour of Scotland can, therefore, be summarised as follows: little sunshine, but also not much rain and no storms. It was cool, though not cold, and cloudy in general.

T.M.L. Wigley and N.J. Huckstep

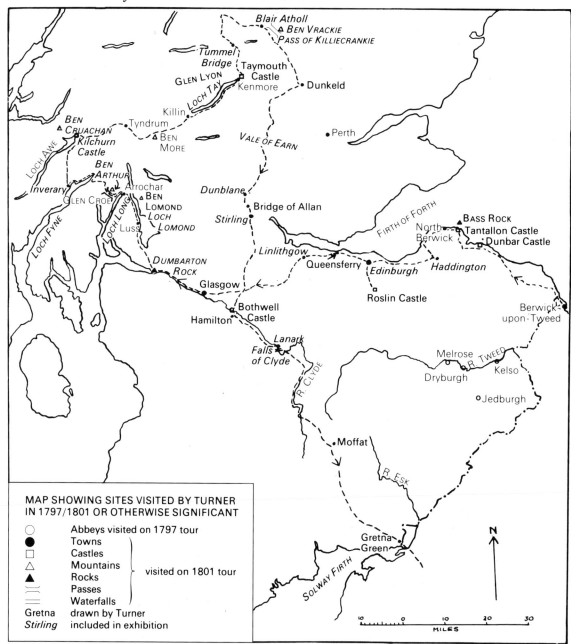

MAP SHOWING SITES VISITED BY TURNER
IN 1797/1801 OR OTHERWISE SIGNIFICANT

○ Abbeys visited on 1797 tour
● Towns
□ Castles
△ Mountains
▲ Rocks visited on 1801 tour
≋ Passes
≋ Waterfalls
Gretna drawn by Turner
Stirling included in exhibition

N

MILES
10 0 10 20 30

The 1797 and 1801 Tours

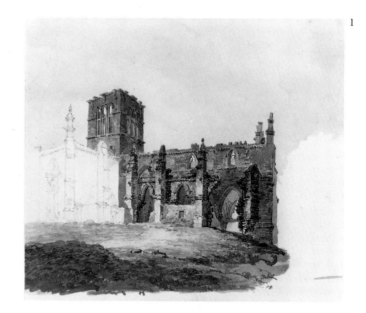

1
**The Ruined Abbey at
Haddington** c.1794
Watercolour over pencil, 175 × 203
Wilton 73
Visitors of the Ashmolean Museum, Oxford

This drawing from the Ruskin School
Collection was copied from an engraving
after Thomas Hearne (dated 1786) from
volume I of *The Antiquities of Great
Britain*. Stylistically the drawing predates
Turner's first visit to Haddington in 1801.
For a full discussion see L. Herrmann,
Ruskin and Turner, London, 1968, No.60.
Thomas Hearne was one of Dr Thomas
Monro's favourite artists and Turner often
copied his work; he was first associated
with Monro by 1793.

2
Edinburgh Castle c.1794
Pencil and watercolour, 180 × 247
Wilton 74
Trustees of the British Museum
(1878-12-28-49)

Copied from a print after Thomas Hearne
dated (1780.) This copy and No.1 show
Turner's interest in Scottish monuments
before he first crossed the Border in 1797.

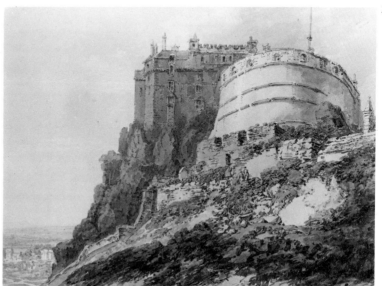

3a

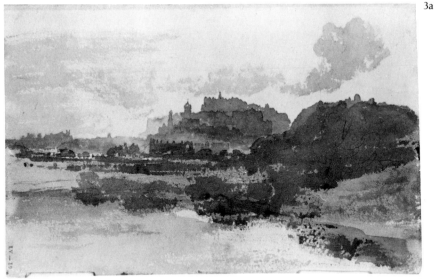

p.10

3

'Edinburgh' Sketchbook 1801
Inscribed on the label on the back: '117
Edinburg'
Bound in marbled cardboard with leather
spine, 78 leaves, the majority drawn in
pencil, some with grey washes or
watercolour, 195 × 126
Trustees of the British Museum (TB LV)

Open at page 10 showing Edinburgh from
St. Margaret's Loch, with Calton Hill on
the right. Turner treated the cityscape in
terms of landscape so one is always aware
of the underlying rocky ground structure
that determines Edinburgh's contours. To
get the maximum verticality when
sketching the Castle from the Grassmarket
or the steep gorge spanned by the Dean
Bridge, he turned his sketchbook sideways
and used the double spread on end.

 The subtly gradated wash drawing at
which the sketchbook is opened has
similarities in treatment to the atmospheric
distant view of 'Edinburgh from above
Duddingston' (No.4)

4

**Edinburgh, from above
Duddingston** c.1801
(reproduced in colour opposite p.32)
Watercolour, 258 × 411
Wilton 320
National Gallery of Ireland, Dublin

5

Edinburgh Castle (Edinburgh from the
Water of Leith) c.1802
Watercolour and scraping out over pencil,
610 × 673
Wilton 347a
Graves Art Gallery, Sheffield

This drawing may have been trimmed at
the top and left sides.

[30]

3b

p.52 St. Bernard's Well with distant view of Firth of Forth and Arthur's Seat

6

Edinburgh from Calton Hill R.A.1804
Watercolour, 660 × 1004
Wilton 348
Trustees of the British Museum (TB LX-H)

7

Linlithgow Palace, Scotland Turner's
Gallery 1810
Oil on canvas, 914 × 1220
Wilton P.104; Butlin and Joll 104
Walker Art Gallery, Liverpool

This somewhat conventional landscape,
with reminiscences of Richard Wilson, was
appreciated by the critics when it was
shown at the Royal Manchester Institution
in 1829: 'Ah, Turner, Turner! Why will
you not paint thus now? Why will you not
leave gamboge, maguilp, and quackery,
and return to nature?' (*Manchester
Guardian*, 29 August 1829).

8

Joseph Mawman, *An Excursion to the
Highlands of Scotland and the English
Lakes, with Recollections, Descriptions and
References to Historical Facts*, London
1805.
Aberdeen University Library

Open at Turner's view of Loch Lomond
(engraved by J. Heath, opposite p.167),
taken from near the village of Tarbet. The
twenty-four mile lochside road then
afforded better views being situated
higher up the hillside than the present
one. The accompanying text praises the
beauty of the shorelines, the islands and
Ben Lomond in fulsome terms.
There is a 'Scottish Pencil' study of Loch
Lomond from a different viewpoint,
(LVIII-1). Both the *Scotch Lakes* and
Tummel Bridge sketchbooks contain

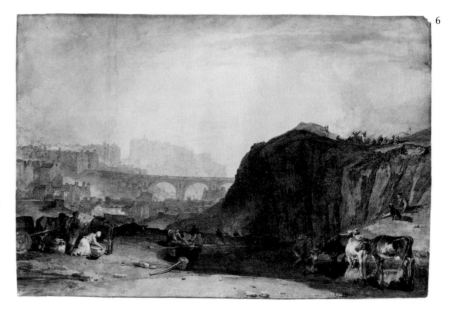

6

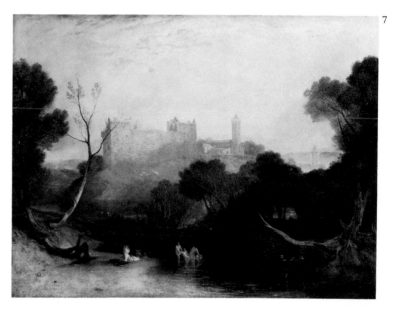

7

drawings of Ben Lomond. See also No.17.

Turner was later to do a watercolour of the head of Loch Lomond to be engraved as a vignette for Roger's *Poems*, London, 1834, illustrations by Turner and Stothard, engraved by W. Miller, p.203. (TB CCLXXX-182).

Mawman writes of Loch Lomond and its area:

'Next morning we set off for Loch Lomond. [From Arroquhar] After proceeding some time on a gentle acclivity, we began to descend towards this celebrated lake. . . . Proceeding among rocks, through woods, and along the verge of precipices, down a road cut with infinite difficulty and labour, we gradually approached Loch Lomond, the chief of British waters. . . . Sometimes we caught through the foliage the glimmering of its surface, and at length from a wide opening, on the edge of a rock hanging over the lake, enjoyed a full prospect of its vast expanse, winding amidst lofty hills; . . . the lofty mountains sloping to the water's edge, and Ben-Lomond towering above the whole, formed a mass of more beautiful and magnificent scenery than is anywhere to be found in Britain. The road continuing elevated along the side of the lake (twenty-four miles in length) and occasionally hilly, is admirably calculated to display its grandeur.

The view from near the village of Torbet (as represented in the annexed plate) [sic] the lake spread before, its sides and dingles on the right filled with ash and beech trees, and contrasted with the nakedness of the opposite crags, and the blue mountains with their fleecy lines imperceptibly melting into clouds, struck us as exquisitely beautiful.'

9

Loch Long, Morning c.1801
(reproduced in colour opposite p.33)
Watercolour, 341 × 486
Trustees of the British Museum (TB LX-F)

Despite its now faded condition, this beautiful watercolour study captures the limpid shallows at the head of Loch Long. Dark accents: the pier, the boats, the promontory in shadow, subtly increase the glow of early morning light reflecting from the water. The view relates to No.10.

A related study is in the *Tummel Bridge* sketchbook, 4a–5.

10

Loch Long and Mountains ('Scottish Pencil') c.1801
Pencil and white body colour on buff prepared ground, 293 × 427 (uneven)
Trustees of the British Museum
(TB LVIII-47)

In the 'Scottish Pencils', Turner used the pencil as the vehicle for conveying his impressions of the Scottish landscape. In the atmosphere created by the clearing after rain, there can be virtually no colour and the landscape assumes a tonal quality comparable to the watercolours of J. R. Cozens (which Turner had copied at the house of Dr Thomas Munro in London). This almost colourless landscape was apparent this April when the cataloguer followed Turner's 1801 tour. The mists have the effect of softening some of the contours and accentuating others, flattening out the mountains like lighted stage flats.

In the west of Scotland wet and fine days can succeed each other, alternating with a dramatic suddenness unknown in the south of England. The wet days may suddenly clear allowing shafts of sunlight to pick out the mountains for an interval, or arching a rainbow over the landscape. These clear periods have to be snatched by the painter or photographer before the mists again descend and the rain recommences.

It seems probable that during the downpours Turner may have worked up the 'Scottish Pencils' from sketchbook studies, taking advantage of the periods when visibility was virtually nil in the open. He cannot have had much in the way of paints with him, which may have been another practical reason for the use of pencil.

Turner started by toning the paper on which the 'Scottish Pencils' are drawn. He reported to Farington that he used a mixture of tobacco juice and water. There seems no reason to doubt this. Whilst on tour in the Highlands of Scotland artists' materials would be unavailable to him, and ingenuity would of necessity come into play. Turner evidently wanted a toned paper from which to work up to his highlights: the gleam of a burn or mists settling over the mountains. The *Tummel Bridge* sketchbook has some pages toned in a dark purplish-brown and others in a stone colour. Possibly this was to allow for both heavily overcast days and finer ones, typical of a present-day July in the west of Scotland.

11

Near Arrochar (?) ('Scottish Pencil') c.1801
Pencil, black chalk and white body colour on buff prepared paper, 312 × 481 (uneven)
Trustees of the British Museum (TB LVIII-6)

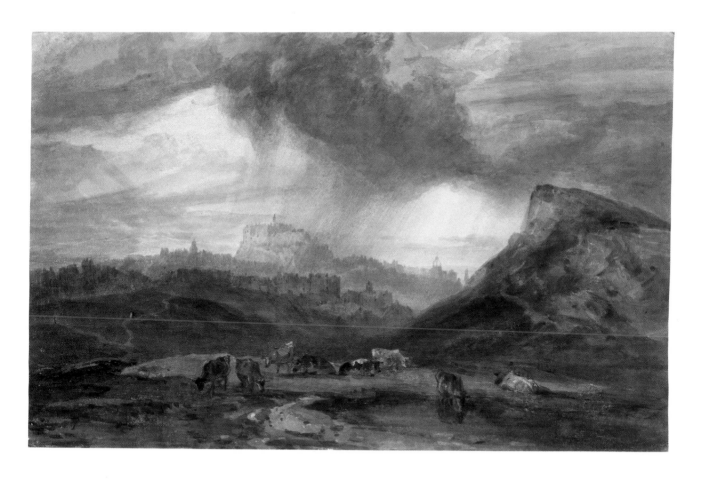

4 Edinburgh from above Duddingston (*c.*1801)

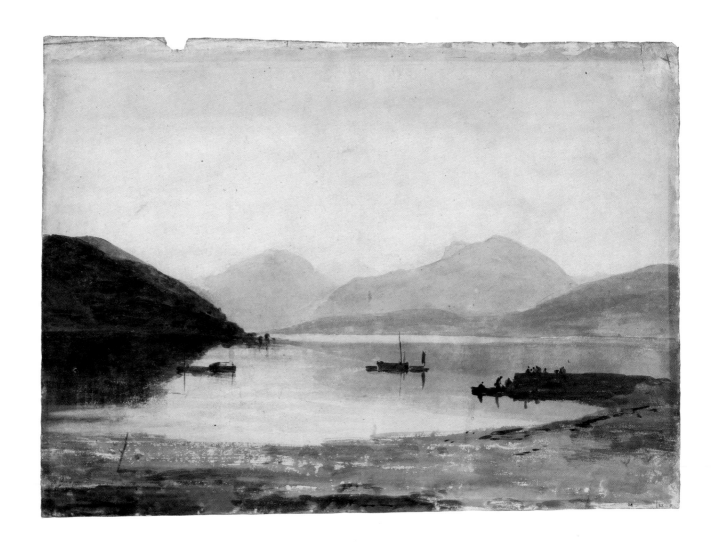

9 Loch Long, Morning (*c.*1801)

12
Ben Arthur ('Scottish Pencil') c.1801
Pencil and white body colour on buff
prepared ground, 346 × 491 (uneven)
Trustees of the British Museum (TB LVIII-2)

Ben Arthur seems to have made a deep
impression on Turner. In addition to this
study there are four other 'Scottish
Pencils' (3, 4, 5, 51) showing various
aspects of the mountain and it was the
subject of one of the *Liber Studiorum* prints
(see No.42). It appears to have been based
on a swift notation in the *Tummel Bridge*
sketchbook (10a-11).
 This study is taken from a lower
viewpoint than the *Liber Studiorum* print.
The outlines of the mountains are precisely
the same, but in the print the cloud
shadows have carved a great scoop out of
the valley altering the overall appearance
of the mountain range.

13
Clouds and Hills at Inverary 1801
Pencil and grey wash, 260 × 411
Visitors of the Ashmolean Museum, Oxford

Turner seems to have spent several days in
and around Inverary on Loch Fyne,
partially because he seems to have hit a
spell of fine weather, but also probably
because he had a commission from the
Duke of Argyll to paint a distant view of
the castle and town (see No.41, *Liber
Studiorum* print of 'Inverary Castle and
Town'). In addition to this painting of
'Inverary Castle' there are five other
watercolours (Nos.14–18) a colour
beginning (TB LX-J), a further *Liber
Studiorum* print of 'Inverary Pier' (No.37),
making a total of fifteen views in this
vicinity, in addition to several drawings in
the *Scotch Lakes* sketchbook and this
sketch.

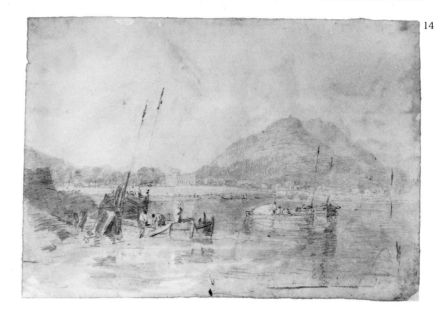

14

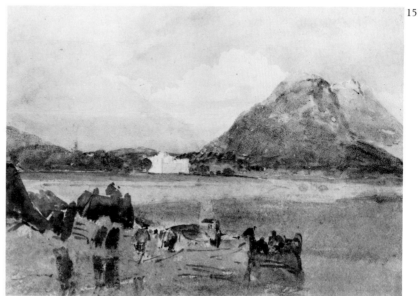

15

[33]

14
Inverary ('Scottish Pencil') c.1801
Pencil and white body colour on buff
prepared ground, 332 × 483
Trustees of the British Museum (TB LVIII-9)

This view looking towards Inverary Castle
and Duniquoich Hill from across Loch
Shira is the one on which the watercolour
TB LX-A was based (see No.15).

15
Inverary Castle c.1801
Pencil and watercolour, 211 × 295
Trustees of the British Museum (TB LX-A)

This view appears to have been taken from
the eastern shore of Loch Shira to the
north of Strone Point, looking across to the
castle and Duniquoich Hill. It is much
faded. It is based on 'Scottish Pencil'
LVIII-9 (No.14).

16
Inverary Pier c.1801
Watercolour, 342 × 490
Trustees of the British Museum (TB LX-B)

This watercolour, which is badly faded, is
identical with the view of 'Inverary Pier'
in the *Liber Studiorum* (No.37).

17
Inverary, Loch Fyne c.1803
(reproduced in colour opposite p.40)
Signed lower right : 'J M W Turner R.A.'
Watercolour, 210 × 295
Wilton 352
City of Manchester Art Galleries

This watercolour was taken from the
south, like most of his Inverary views.
This one is probably from the rocky
outcrop of An Otir. The view is identical
with 'Scottish Pencil' LVIII-10, except for

the fact that Turner has shifted the
position of the castle in this watercolour to
the right in order to bring it into full view.

The steeple of the new church by
Robert Mylne is shown as still being under
construction and unfinished. (See Ian G.
Lindsay and Mary Cosh, *Inverary and the
Dukes of Argyll*, Edinburgh, 1973,
pp.282–286.)

Turner has included a close-up detail of
the herring catch being unloaded from a
Loch Fyne skiff : 'The Loch Fyne skiffs
were rather lightly constructed and seem
not to have lasted very long. Their
beautifully shaped hulls were kept light to
make them fast, for fishing in an area
where gales occurred frequently the
fishermen wanted a craft that could reach
shelter quickly.' Robert Simper, *Scottish
Sail : A Forgotten Era*, Newton Abbot,
1974, p.31. The awning was a practical
addition for protection against adverse
weather.

This drawing was engraved by J. Heath
for Mawman's *Excursion to the Highlands
of Scotland*, 1805, opposite p.144. Mawman
writes of Loch Fyne and Inverary :

'The sun was in his full splendour, and the
whole expanse of water, which from its
smoothness (being above 20 miles from the
sea) and from the winding of its shores,
possesses almost all the beauties of a fresh-
water lake, glittered before us. . . . we soon
beheld opening in front, upon a sloping
lawn, in its mountain recess, the duke of
Argyle's grey, gothic, modern-built castle,
with a beautiful bridge over the Ary, and
the great rock Dunequaich [sic],
surmounted by a watch-tower in front;
while the town of Inverary with its spire
and the lake stretching out to the horizon,
on the left, widening and terminating with
a picturesque bridge over the Spira [sic], to
the right; the road skirting the edge of the

lake to the town, and continuing its course
behind it, . . . the castle and town
sheltered by fine trees, rising shade
above shade, and mountains forming a
semicircular screen stretching to the
clouds, collectively present one of the
most beautiful and sublime pictures that
ever filled the eye of an enraptured
spectator.

On our landing upon the quay, the
impression already received of the beauty
of Inverary, situated on a small peninsula
of the loch, was not diminished Crowded
with herring-busses [sic], reeling at every
ebb and flow, the fore-ground diffused a
lively interest over the romantic scenery in
the distance.'

18
Loch Fyne, Argyllshire 1815
(reproduced on front cover)
Signed and dated lower left : 'J M W
Turner RA 1815'
Watercolour and some scratching out,
278 × 388
Wilton 351
Trustees of the British Museum
(1910-2-12-275)

This view towards the head of Loch Fyne
was painted retrospectively. It was
probably taken from Ardgenavan point
not far from Dunderave Castle, on the
north-west shore. It is based on the
'Scottish Pencil' LXVIII-8. The
atmospheric effect of mist rising from the
valley and the reflections in the waters of
the little bay to the left, are magically
conveyed. The sharpness of form and
colour apparent here, occurs typically in
the clearing after a rain shower in the
western Highlands and Islands.

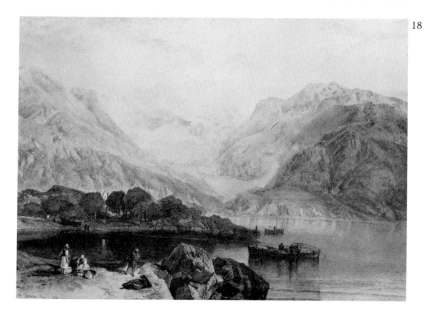

18

19

Kilchurn Castle with Cruchan Ben Mountains (Kilchurn Castle and Loch Awe with Rainbow) R.A.1802 (reproduced in colour between pp.40 and 41)
Watercolour, 533 × 772
Wilton 344
Plymouth City Museum and Art Gallery

Turner seems to have hit another fine spell on Loch Awe for there are many drawings of Kilchurn Castle taken from a wide variety of viewpoints, in the *Scotch Lakes* sketchbook (T B L V I, 42–63), some of them clearly done from a boat. A boat was the recommended way of viewing this castle situated on a small tongue of land projecting into the head of Loch Awe. But rain was never far away, as the rainbow in this picture suggests.

P.G. Hamerton devoted an entire chapter to this painting, claiming it as the turning point in Turner's career when he was 'delivered . . . from the topographic slavery of his youth.' (P.G. Hamerton, *Life of J.M.W. Turner*, London, 1879, Chapter IV.)

Hamerton, who knew the area intimately, affirms that 'Turner's view of Kilchurn is taken from the shore of the river Orchy, at a little distance above the castle.' A railway embankment and a main road now obscure Turner's view , but by going further north-east and standing by the route of the old road (B8077) it is possible to see the castle at the same angle, although from a greater distance.

The drawings in the *Scotch Lakes* sketchbook are very revealing of Turner's approach: he stalks his subject casting a wide circle and closing in on it progressively. The ruined outlines of the castle are studied in relation to the surrounding mountains, and he depicts its reflection imprinted on the water. In the

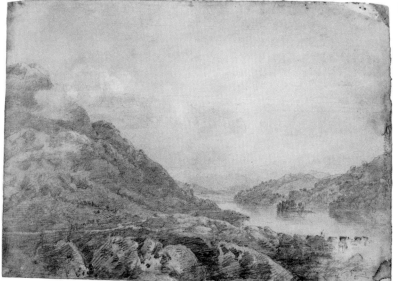

20

final studies Turner was right up close under the walls of the ruin so that it towered above him, seeming to dwarf the surrounding mountains. Despite his studies, Turner blunted the jagged outlines of the castle in this painting as Hamerton pointed out. For further studies of the locality see 'Scottish Pencils' TB LVIII 13-17.

Turner has reduced the size of the castle in relation to the mountains to emphasise the grandeur of its natural surroundings; an alteration consistent with a Romantic approach to landscape. (Discussed by Ruskin, *Modern Painters*, in the section, 'On Turnerian Topography').

William and Dorothy Wordsworth visited Loch Awe in 1803, following a great flood. The scene inspired the poet's 'Address to Kilchurn Castle Upon Loch Awe.' Dorothy described it in her Journal as 'a decayed palace rising out of the plain of waters' (*Journals of Dorothy Wordsworth*, ed. E. de Selincourt, London, 1952, vol.I, p.304).

20
Loch Tay ('Scottish Pencil') c.1801
Pencil and white body colour on buff prepared ground, 340 × 490 (uneven)
Trustees of the British Museum
(TB LVIII-19)

This view was taken from the western end of the loch from near Killin looking eastwards. The inclusion of the wading cattle and the herdsmen lends an idyllic, almost a Claudian aspect, to this peaceful scene. The cattle also give the eye a point from which to measure the immense distance of the loch stretching away into the background.

Farington noted that 'on the whole I preferred the scenery at the head of the lake to that about Kenmore. The latter is

pleasing, but the former has more of the true Character of a mountainous Country, there is greater variety of forms and the enrichments of wood appear more spontaneous' (Farington, p.1651).

For related studies see *Scotch Lakes* sketchbook 85a–90 (the closest is probably 89a–90).

21
Tummel Bridge ('Scottish Pencil') c.1801
Pencil and white body colour on buff prepared ground, 427 × 289 (uneven)
Trustees of the British Museum
(TB LVIII-41)
Related study in *Tummel Bridge* sketchbook, 25a–26.

This vertical composition is taken from the south end of the bridge looking north. It is the only one of Turner's views of Tummel Bridge to remain virtually intact today.

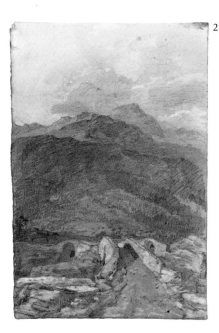

21

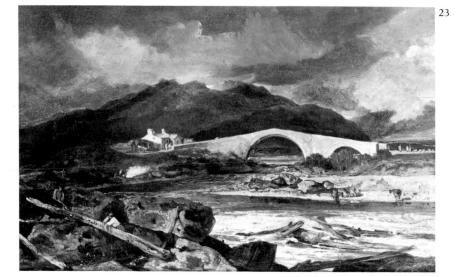

23

22
Tummel Bridge ('Scottish Pencil') c.1801
Pencil and white body colour on buff
prepared ground, 292 × 432 (uneven)
Trustees of the British Museum
(TB LVIII-42)
Related study in *Tummel Bridge*
sketchbook, 23a–24.

Turner has drawn the bridge from close to
at an oblique south-west angle and has
pulled the two arches further apart than
they are in reality.

23
Tummel Bridge, Perthshire c.1802–3
Oil on panel, 280 × 465
Wilton P.41; Butlin and Joll 41
*Yale Center for British Art, Paul Mellon
Collection, New Haven*

The view in this painting is taken from the
east side of the bridge looking westwards,
as in the 'Scottish Pencil' TB LVIII-39.
It is no longer possible to see the views of
the bridge as Turner painted it from either
side, as the eastern aspect is screened by
trees, and a girder bridge has been
constructed immediately to the west of the
old bridge to take traffic. Finberg was not
able to verify Ruskin's identification of the
Tummel Bridge sketchbook drawings or
the 'Scottish Pencils'. A visit to the bridge
in 1982 with photographs of the 'Scottish
Pencils' in hand, left no doubt as to the
correctness of Ruskin's identification.

24
Scottish Mountains ('Scottish Pencil')
c.1801
Pencil and white body colour on buff
prepared ground, 289 × 428
Trustees of the British Museum
(TB LVIII-29)

24
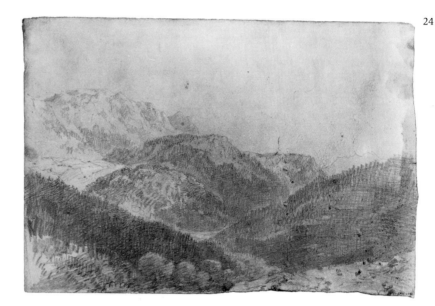

26
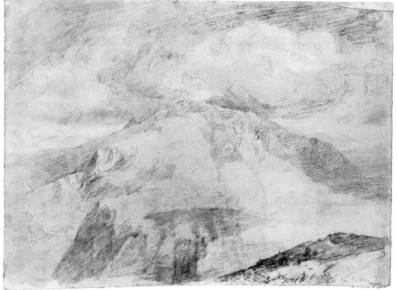

Although this view has not been identified precisely it seems likely that it was taken in the Dunkeld area where Farington admired 'the Hills enriched with plantations not formally made but mixing in a natural manner with the rocks' (Farington, p.1643). The Duke of Atholl was noted for his planting. Alternatively it might be in the Kenmore area where Lord Breadalbane had extensive fir plantations (Farington, p. 1649). For anyone familiar with the west of Scotland, Turner found in the 'Scottish Pencils' an ideal means of conveying the atmosphere and texture of the Scottish landscape. In this drawing, for example, with the utmost economy of pencil strokes, Turner has captured precisely the different textures of hillsides thickly planted with firs and larches and the deciduous trees in the outer belts.

For numerous studies of the Blair Atholl and Dunkeld area see the *Scotch Lakes* sketchbook.

25
Study of Rocks in a Stream ('Scottish Pencil') c.1801
Pencil, watercolour and white body colour on buff prepared ground, 266 × 379 (uneven)
Trustees of the British Museum
(TB LVIII-52)

It seems likely that this drawing of a deep enclosed glen, relates to studies for the *Liber Studiorum* print, 'Blair Atholl' in the *Scotch Lakes* sketchbook. It has been related by Finberg to the watercolour 'A Rocky Pool with Heron and Kingfisher' in Leeds City Art Gallery. For a full discussion see *Turner 1775–1851*, Royal Academy exhibition 1974, No.193.

26
Ben Vrackie ('Scottish Pencil') c.1801
Pencil and white body colour on buff prepared ground, 344 × 481 (uneven)
Trustees of the British Museum
(TB LVIII-37)

Ben Vrackie is one of the most impressive of the Perthshire mountains. The clouds rising over its summit are perfectly conveyed in touches of white wash above the pencilled flanks of the mountain. The immensity and the verticality of its steep sides are emphasised by the inclusion of a minute human figure, no bigger than an exclamation point, at the lower right.

27
Killiecrankie ('Scottish Pencil') c.1801
Pencil on buff prepared ground, 336 × 483 (uneven, badly torn upper and lower edges)
Trustees of the British Museum
(TB LVIII-36)

This is unusual amongst the 'Scottish Pencils' in the stress on the human element. The domestic scene of the cottages and the seated woman with a child at her knee, in contrast to the rugged heights of the surrounding mountains, give it a rustic charm – almost a dash of Gainsborough. Turner is here at his most picturesque. It is based on the drawing in the *Scotch Lakes* sketchbook 131a–132.

28
A Mountain Torrent ('Scottish Pencil') c.1801
Pencil, watercolour and white body colour on buff prepared ground, 483 × 344
Trustees of the British Museum
(TB LVIII-34)

Turner visited the famous Falls of Bruar and a drawing in the *Scotch Lakes* sketchbook (135a–136) shows the bridge over the lower fall of Bruar. It is not impossible that this mountain torrent was in the same area. For a contemporary description of the Bruar Falls see Farington, p.1646. There are however a number of waterfalls that were visited by tourists in this part of Scotland.

Farington saw the following falls in addition: Rumbling Brig and Cauldron Glyn, the waterfall by the Hermitage (or Ossian's Hall) near Dunkeld, the Falls of Moness (from Aberfeldy), the Falls of Acharn (from Kenmore), the Fall of Coilig (Glen Lochay), the Falls of the River Dochart (near Killin) and the Falls of Glen Shira (near Inverary).

For the importance of Perthshire waterfalls to the 'picturesque' tourist and artist, see David Irwin, 'A Picturesque Experience: The Hermitage at Dunkeld', *Connoisseur*, vol.187, 1974, pp.196–201.

29
Dunblane c.1801
Pencil, 261 × 404
Visitors of the Ashmolean Museum, Oxford

This drawing was in the Ruskin School Collection and came from the *Smaller Fonthill* sketchbook. Related studies are: the *Scotch Lakes* sketchbook (TB LVI) 145a–146. For a full discussion see L. Herrmann, *Ruskin and Turner*, p.91. Both this and No.30 must have served as the basis for the *Liber Studiorum* plate (No.40).

30
Dunblane c.1801
Pencil, 267 × 413
Society of Friends of Dunblane Cathedral

This view, also from the *Smaller Fonthill* sketchbook, is taken from below but further upstream than the Ashmolean's drawing. The buildings to the left are the ruins of the old Bishop's Palace. They appear in the same relation to the Cathedral, although from a different viewpoint, in the print in John Slezer's *Theatrum Scotiae*. They were demolished in the later nineteenth century.

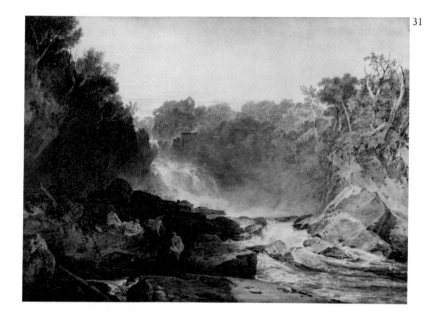

31

**The Fall of the Clyde, Lanarkshire:
Noon–Vide Akenside's Hymn to the
Naiads** R.A.1802
Watercolour, 745 × 1058
Wilton 343
Walker Art Gallery, Liverpool

Other studies are in the National Gallery of Scotland, the Fogg Art Museum and the Pantzer Collection, Indianapolis. When Farington saw Cora Linn in 1792 he remarked in his diary: 'More cannot be said than that it is so perfect a composition to speak the language of art, as to leave no room for proposing an alteration in any of the accompaniments.'

Akenside's *Hymn* had been published in 1746, and in the 'Argument' preceding the poem he had written of 'Nymphs who preside over springs and rivulets' giving 'motion to the air, and exciting summer breezes; . . . nourishing and beautifying the vegetable creation.'

For a discussion of the late eighteenth and the nineteenth century interest in the falls of the Clyde, see David Irwin, 'Three Foaming Cataracts', *Country Life*, 5 May 1977, which reproduces No.31 together with other artists' views.

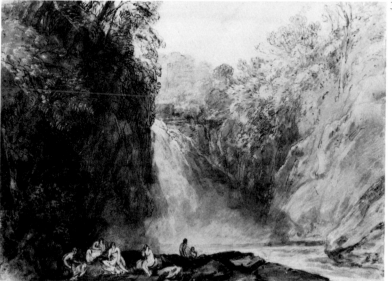

32

Falls of Clyde c.1806
Pen and brown ink with wash, with stopping out and scraping out, 185 × 260
Trustees of the British Museum (TB CXVI-U)

This and the next item were made in preparation for plates in the *Liber Studiorum*.

33

Peat Bog c.1806
Pen and brown ink and wash, with stopping out and scraping out, 188 × 266
Trustees of the British Museum (TB CXVII-T)

34

Solway Moss 1801
Pencil and grey wash, 255 × 413
Visitors of the Ashmolean Museum, Oxford

From the *Smaller Fonthill* sketchbook. For a full discussion see L. Herrmann, *Ruskin and Turner*, No.67. Related studies are in the *Scotch Lakes* sketchbook, (TB LVI 179a-180, 180a-181).

35–42

Liber Studiorum 1807–19

These plates were issued in fourteen parts between 1807 and 1819. Each part contained five plates and in addition there was a frontispiece making seventy-one plates in all. Twenty further designs were not published. The plates are executed in etching and mezzotint. Turner himself etched the majority, before handing the plate on to the engraver.

Turner's aim seems to have been to illustrate the various categories into which landscape painting can be divided. At the same time the *Liber Studiorum* is a demonstration of Turner's own range as a landscape artist. The plates are divided by Turner under five headings: Historical, Mountainous, Pastoral, Marine, and Architectural. Turner added a sixth category which he left unexplained; 'E.P.', standing, it is thought, for either 'Elevated', 'Epic' or 'Elegant' Pastoral. 'The Falls of Clyde' belongs to this last category.

There are eight Scottish plates exhibited here all based on sketches, watercolours or drawings made on his 1801 tour.

35

The Fall of the Clyde 1809
Inscribed on the plate: 'E.P. / Drawing of the CLYDE. In the possession of J. M. W. Turner. / Drawn & Etched by J. M. W. Turner Esq^r. R.A.P.P. / Engraved by C. Turner / London, Published March 29. 1809, by C. Turner, N^o 50. Warren Street, Fitzroy Square.'
Etching and mezzotint, subject 182 × 264; plate 209 × 211
Rawlinson 18; first published state
Royal Academy of Arts, London

36

Near Blair Atholl 1811
Inscribed on the plate: 'M / NEAR BLAIR ATHOL SCOTLAND / Drawn & Etched by J. M. W. Turner Esq^r R.A, / Engraved by W. Say. Engraver to H.R.H. the Duke of Gloucester / Published June 1 1811, by J. M. W. Turner, Queen Ann Street West.'
Etching and mezzotint, subject 180 × 264; plate 207 × 292
Rawlinson 30; first published state
Royal Academy of Arts, London

There are related sketches in the *Scotch Lakes* sketchbook, 116a–117, 118, 118a, 119a–120, 121.

37

Inverary Pier 1811
Inscribed on the plate: 'M / INVERARY-PIER. LOCH FYNE. MORNING. / Drawn Etched & Engraved by I. M. W. Turner R.A. / Published June 1. 1811, by I. M. W. Turner, Queen Ann Street West.'
Etching and mezzotint, subject 177 × 263; plate 214 × 290
Rawlinson 35; first published state
Royal Academy of Arts, London

See the watercolour of Inverary, No.16.

38

Peat Bog, Scotland 1812
Inscribed on the plate: 'M / PEAT BOG, SCOTLAND / Drawn & Etched by I. M. W. Turner Esq^r R.A. / Engraved by G. Clint / Published April 23. 1812, by I. M. W. Turner, Queen Ann Street West.'
Etching and mezzotint, subject 175 × 258; plate 206 × 288
Rawlinson 45; first published state
Royal Academy of Arts, London

See No.33 for a related pen and wash study.

39

Solway Moss 1816
Inscribed on the plate: 'P / SOLWAY MOSS. / Drawn & Etched by I. M. W. Turner R.A. / Engraved by Tho^s Lupton / Published Jan^y 1. 1816, by M^r Turner, Queen Ann Street West.'
Etching and mezzotint, subject 182 × 268; plate 205 × 288
Rawlinson 52; first published state
Royal Academy of Arts, London

See No.34.

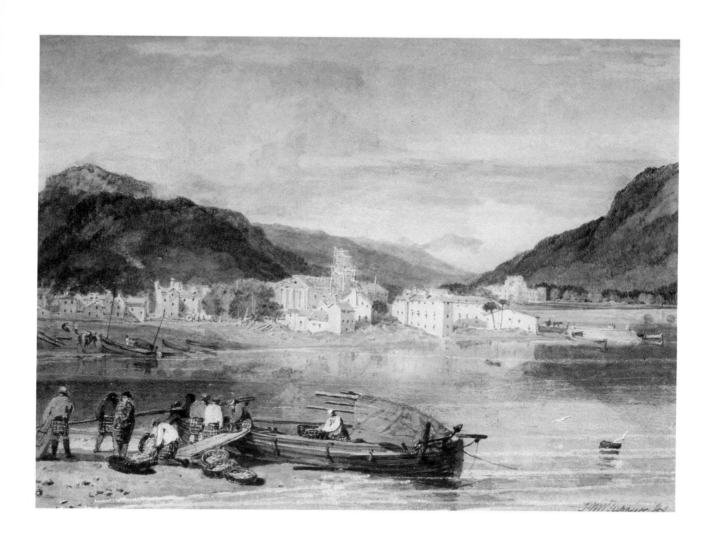

17 **Inverary, Loch Fyne** (*c*.1802–3)

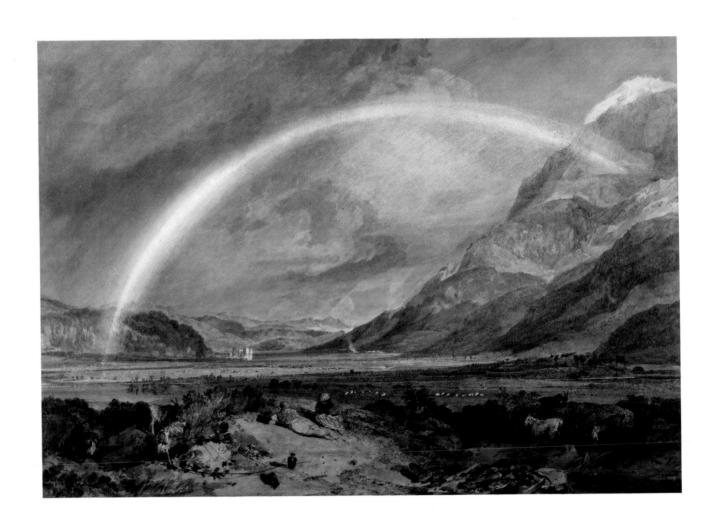

19 **Kilchurn Castle with the Cruchan Ben Mountains, Scotland: Noon** (R.A. 1802)

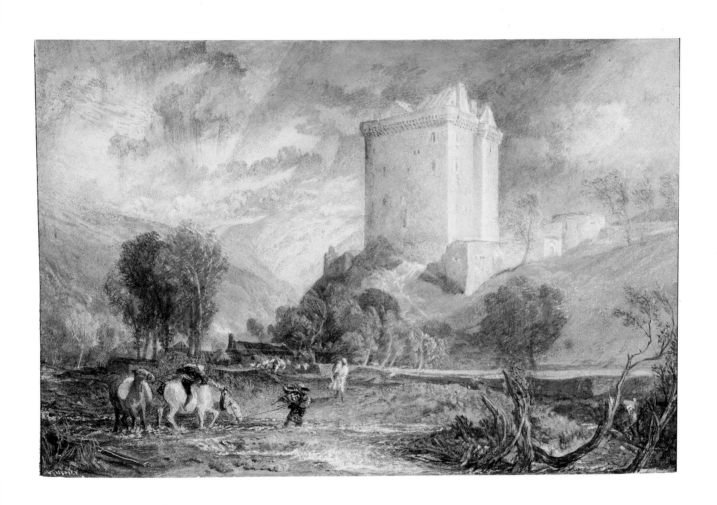

45 **Borthwick Castle** (*c.*1818)

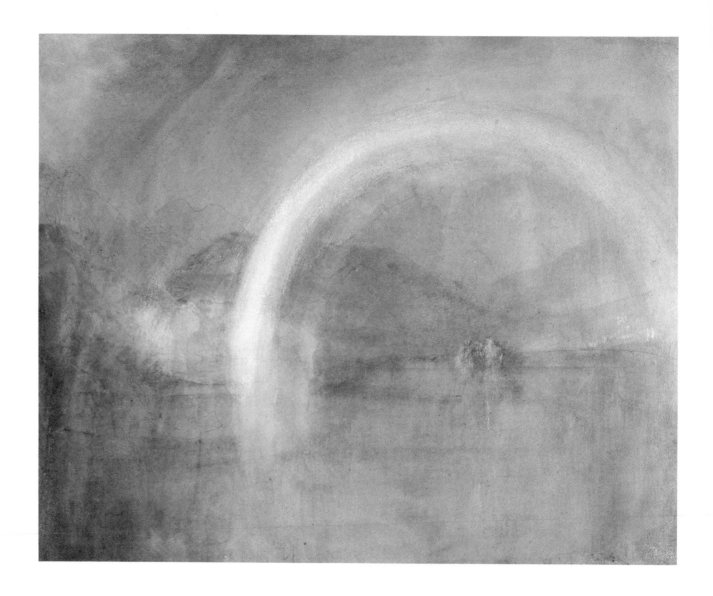

63 Loch Awe with a Rainbow

40

Dunblane Cathedral 1816
Inscribed on the plate: 'A / DUMBLAIN
ABBEY [*sic*], SCOTLAND. / Drawn &
Etched by I. M. W. Turner Esq. R.A. /
Engrav'd by T. Lupton. / Publish'd Jan.ʸ 1,
1816. by I. M. W. Turner, Queen Ann
Street West.'
Etching and mezzotint, subject 183 × 265;
plate 207 × 287
Rawlinson 56; first published state
Royal Academy of Arts, London

A site visit by the cataloguer revealed that
Turner has doubled the actual height of
the steep bank on which the cathedral is
built. In addition he has altered the course
of the river to make it appear that the
cathedral is situated on a promontory. See
also Nos.29 and 30.

41

Inverary Castle and Town 1816
Inscribed on the plate: 'M / INVERARY
CASTLE AND TOWN, SCOTLAND. / the
Drawing in the Possession of the Duke of
Argyle. / Drawn & Etched by I M W
Turner / Engraved by C Turner / Pub Jan
1. 1816. by I. M. W. Turner Queen Anne
Street West'
Etching and mezzotint, subject 179 × 255;
plate 209 × 290
Rawlinson 65; first published state
Royal Academy of Arts, London

This view must have been taken between
three and four miles south down the
western shore of the loch. The print is
based on the watercolour painted for the
Duke of Argyll, 'Loch Fyne with Inverary
Castle in the Distance' (Wilton 349), now
in the Yamanashi Prefectural Museum of
Art, Japan.
 Turner evidently encountered varied
weather conditions during his sojourn at

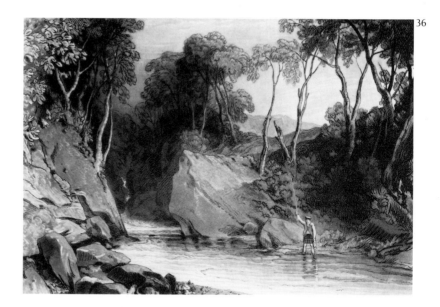

36

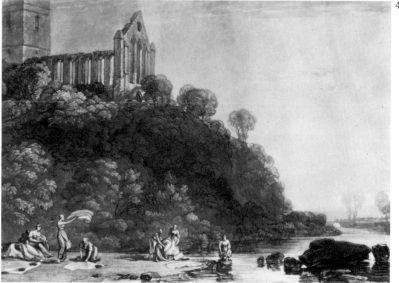

40

42

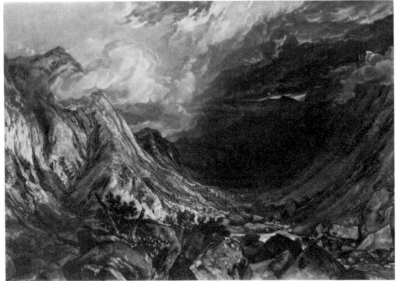

Inverary, although he seems to have hit a fine spell. The scenes range from the threatening skies and disturbed water shown in this print to the tranquillity apparent in 'Inverary, Loch Fyne' (No.17).

It is noteworthy that Farington on visiting Inverary in October of the same year, saw two paintings of Inverary done by Alexander Nasmyth for the Duke: 'one a view of Inverary from the water, the other of a waterfall up Glen Strecher [Shira] at the Head of the Loch.'

42
Ben Arthur 1819
Inscribed on the plate: 'M / BEN ARTHUR, SCOTLAND. / Drawn. & Etched by I.M.W. Turner Esq. R.A.P.P. / Engraved by T. Lupton. / London. Pub. Jan 1. 1819. by I.M.W. Turner Queen Anne Str West.'
Etching and mezzotint, subject 180 × 267; plate 206 × 288
Rawlinson 69; first published state
Royal Academy of Arts, London

Related studies: See 'Scottish Pencil' LVIII–2 (No.12).

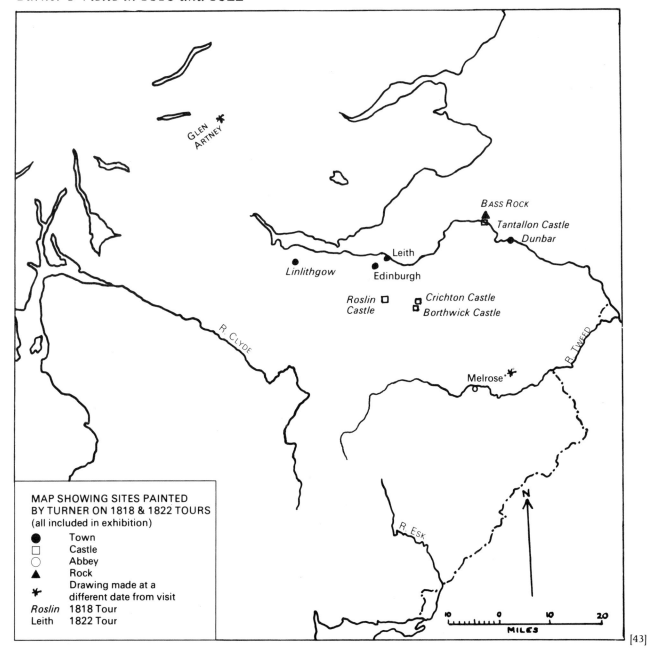

GLEN
ARTNEY ✳

BASS ROCK ▲
Tantallon Castle
● Dunbar

Leith ●
Linlithgow ●
● Edinburgh

Roslin □ □ *Crichton Castle*
Castle □ *Borthwick Castle*

R. CLYDE

R. TWEED

Melrose ✳
○

R. ESK

N
↑

MAP SHOWING SITES PAINTED
BY TURNER ON 1818 & 1822 TOURS
(all included in exhibition)
● Town
□ Castle
○ Abbey
▲ Rock
✳ Drawing made at a
different date from visit
Roslin 1818 Tour
Leith 1822 Tour

10 0 10 20
MILES

[43]

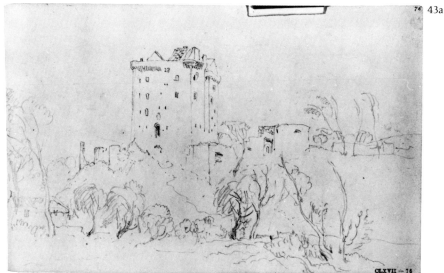

43a

p.76 Borthwick Castle

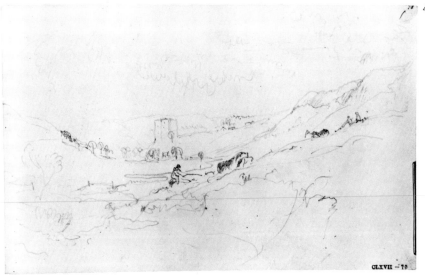

43b

p.70 Hilly Landscape with men ploughing, castle in distance

43
'Scotch Antiquities' Sketchbook 1818
Inscribed: 'Scotch Work' on cover, and
'89 Scotch Antiquities' on spine
Bound in buff boards, 90 leaves, the
majority drawn on in pencil 112 × 184
Trustees of the British Museum (TB CLXVII)

Open at page 76 showing Borthwick
Castle. This sketchbook was used by
Turner on his journey to Scotland in
October and November 1818 to gather
material for Scott's *Provincial Antiquities of
Scotland*. It includes studies of Edinburgh,
Roslin, Crichton, Borthwick, Tantallon
and Dunbar. Most of the ten finished
watercolours used as illustrations are
based on studies in this sketchbook.

44
Crichton Castle with Rainbow c.1818
Watercolour, with traces of pencil,
173 × 239
Wilton 1143
*Yale Center for British Art, Paul Mellon
Collection*

This is a study for one of Turner's
illustrations for Scott's *Provincial
Antiquities of Scotland*. A colour-beginning
for the same subject is in the *Scotland and
Venice* sketchbook (TB CLXX-4). The
rainbow does not appear in the finished
design. Crichton Castle is further discussed
in the entry for Nos.48–55.

[44]

44

47

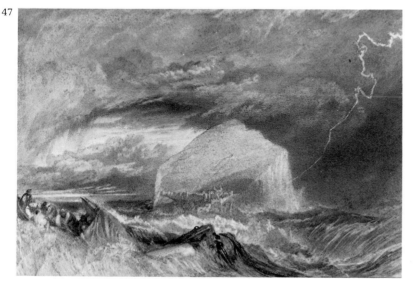

45

Borthwick Castle c.1818
(reproduced in colour between pp.40 and 41)
Signed lower left: 'Turner'
Watercolour and scraping out, 160 × 249
Wilton 1060
*Indianapolis Museum of Art; Gift in
memory of Dr and Mrs Hugo O. Pantzer*

This watercolour is based on a pencil
drawing in the *Scotch Antiquities*
sketchbook (TB CLXVII-76). Two more
studies are in the *Scotland and Venice*
sketchbook (TB CLXX, pp.1, 2). *Borthwick
Castle* was engraved by H. Le Keux in 1819
for the *Provincial Antiquities*. Sir Walter
Scott was the first owner.

46

Roslin Castle (Hawthornden) c.1823
Signed lower right: 'Turner'
Watercolour, 175 × 265
Wilton 1065
*Indianapolis Museum of Art: Gift in
memory of Dr and Mrs Hugo O. Pantzer*

This drawing presents a dating problem.
Although the plate engraved from it by
W.R. Smith is dated 1822, the sheet of
paper on which it is drawn is water-
marked 1823. The drawing, first owned by
Sir Walter Scott, is based on a pencil
sketch in the *Scotch Antiquities* sketchbook
(TB CLXVII-66).

47

The Bass Rock c.1824
Watercolour, 159 × 254
Wilton 1069
Lady Lever Art Gallery, Port Sunlight

For related studies see the *King's visit to
Scotland* sketchbook (TB CC-79) and
probably also other studies in the *Bass
Rock and Edinburgh* sketchbook

CTB CLXV, 5–6, 37a, 38). The drawing was engraved by W. Miller for *The Provincial Antiquities*, vol.II, in 1826.

48–55
Sir Walter Scott, *The Provincial Antiquities and Picturesque Scenery of Scotland*, 1819–26

In 1818 Turner was invited by Sir Walter Scott to contribute twelve illustrations to accompany the text of *The Provincial Antiquities and Picturesque Scenery of Scotland*. The prestige that Turner's name would lend to the publication which was to be issued in parts, was a prime consideration and is reflected in the contract: Turner was to be paid more than twice as much as Edward Blore and the Revd. John Thomson of Duddingston who were likewise shareholders in the scheme. Thomson contributed ten plates and Blore nineteen. Three engravers, George Cooke, Henry Le Keux and William Lizars were similarly engaged. Other artists involved to a lesser degree were A.W. Calcott who was responsible for five views, J.C. Schetky who produced two, and H.W. Williams, Alexander Nasmyth and Andrew Geddes who contributed only one plate each. The initial scheme was for the text to be written around the illustrations, but this soon proved to be impractical on account of the difficulties of having the plates ready on time and in the right sequence. From about 1821 therefore, Scott's text was more loosely connected with the plates. (For a full discussion see G. Finley, *Landscapes of Memory*, London, 1980, pp.56–61).

Turner's plates are infinitely more Romantic than those of his collaborators. His view of Roslin Castle (No.52) towers over the steep glen which Scott described as 'impend[ing] over and threaten[ing] the

spectator'. Tantallon Castle (No.54) perched on its promontory exactly matches Scott's description of its 'striking situation overhanging the billows of a wide and often troubled ocean'. Turner's two other coastal views of the Bass Rock and Dunbar (Nos.55 and 53), both include raging seas and shipwrecks in the immediate foreground. Dunbar was described by Scott as having been virtually impregnable, a point which Turner's treatment underlines.

Turner reached Edinburgh by late October having taken in Dunbar and North Berwick, from where he sketched Tantallon Castle and the Bass Rock en route. The tour lasted two weeks and three sketchbooks were filled, of which the *Scotch Antiquities* is on display (No.43). From Edinburgh Turner made excursions to Crichton, Roslin and Borthwick Castles to the south-east of the city and re-visited Linlithgow to the west, where he had already made drawings in 1801.

A colour-beginning of Crichton Castle is included in the exhibition (No.44). This castle was described by Scott as 'romantic ruins . . . well deserving of a visit, whether from the antiquary, the admirer of the picturesque or he who seeks the scenes of historical events.'

The two title-page vignettes (Nos.56–57) were an afterthought and date from Turner's fourth visit to Scotland in 1822, on the occasion of George IV's state visit. Volume I shows the King's procession to Edinburgh Castle with the Regalia, the history of which is dealt with in the first volume. The title vignette for volume II represents the King being welcomed to Scotland by Sir Walter Scott, symbolised by the clasped hands. The national emblems below the royal ship were added in the engraved version.

Turner was on friendly terms with the

genial minister John Thomson of Duddingston (the amateur artist much favoured by Scott). On one occasion the two of them together with H.W. Williams sketched at Craigmillar Castle. But Turner's odd social behaviour and his secrecy over his sketches which he refused to show to his fellow artists, did not endear him to the Edinburgh artists in general. For Turner's influence on his Scottish contemporaries, see David and Francina Irwin, *Scottish Painters: At Home and Abroad 1700–1900*, London, 1975, Chapter 12.

Sir Walter Scott owned the original illustrations by Turner; eight of them he kept in his Breakfast Room, framed in an oak frame made from a tree on the Abbotsford estate.

Unfortunately the venture turned out to be a financial failure, creating a source of discord between Scott and Turner, and causing considerable financial embarrassment to Thomson of Duddingston. (For a full discussion see Finley, op.cit., pp.65–68.)

48
Sir Walter Scott, *The Provincial Antiquities and Picturesque Scenery of Scotland*, 1826

Both volumes of the two-volume set, published by John and Arthur Arch in London and William Blackwood in Edinburgh
National Gallery of Scotland

Volume I is open at the view of 'Linlithgow Palace', and volume II at the plate of 'Edinburgh High Street'.

49–55
Seven mounted prints
Trustees of the British Museum

49
Crichton Castle
Engraving on copper, by George Cooke,
248 × 162
Rawlinson 190

50
Borthwick Castle
Engraving on copper, by H. Le Keux,
248 × 162
Rawlinson 191

51
Heriot's Hospital
Engraving on copper, by H. Le Keux,
241 × 162
Rawlinson 195

52
Roslin Castle
Engraving on copper, by W.R. Smith,
240 × 159
Rawlinson 196

53
Dunbar
Engraving on copper, by J.C. Allen,
257 × 172
Rawlinson 197

54
Tantallon Castle
Engraving on copper, by E. Goodall,
241 × 162
Rawlinson 198

55
The Bass Rock
Engraving on copper, by W. Miller,
254 × 159
Rawlinson 200

49
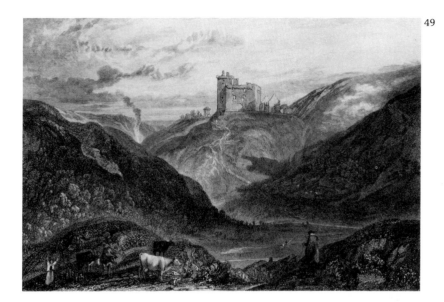

54
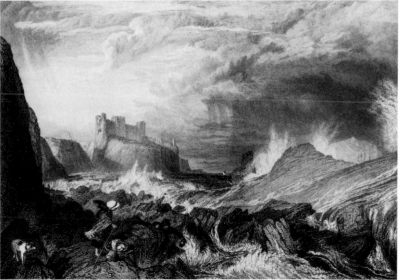

[47]

57

56
Edinburgh Castle : *Provincial Antiquities of Scotland*, title vignette, vol.I c.1825
Signed lower right : JMWT ; inscribed above : PROVINCIAL ANTIQUITIES / of Scotland / NEMO ME IMPUNE LACESSIT and inscribed below : London
Pencil and grey wash, 198 × 130
Wilton 1058
Trustees of the British Museum
(TB CLXVIII-A)

Turner made sketches for these two vignettes on the occasion of George IV's visit. This shows the King's procession with the Regalia to Edinburgh Castle. Both vignette designs were engraved for the published volumes, this one by G. Cooke and the next one by R. Wallis.

57
Edinburgh from Leith harbour :
Provincial Antiquities of Scotland, title vignette, Vol. II c.1825
Signed lower left : JMWT ; and inscribed above : PROVINCIAL ANTIQUITIES / of Scotland / with . . . / Vol 1 TR2 / DIEU ET MON DROIT (repeated)
Pencil on grey wash, 206 × 157
Wilton 1063
Trustees of the British Museum
(TB CLXVIII-B)

58
George IV in Scotland. The landing at Leith 1822
Pencil, 174 × 301
Trustees of the British Museum (TB CCIII-J)

In 1822 George IV paid a state visit to Scotland, the colourful pageantry for which was devised by Sir Walter Scott. Turner arrived a few days in advance of the King and stayed for at least two weeks. The scene in this drawing took place on 15 August.
 The 'Royal Progress' compositions have been thoroughly discussed by Gerald Finley in *Turner and George IV in Edinburgh*, London, 1981. There are related studies in the *King's Visit to Scotland* sketchbook (TB CC p.58a)

59
Edinburgh Castle, March of the Highlanders c.1835
Watercolour, 86 × 140
Wilton 1134
Tate Gallery, London

This was engraved by T. Higham as one of the plates for *Fisher's Illustrations to the Waverly Novels*, 1836–7 (Rawlinson 560). It records the Highlanders ascending Calton Hill for the ceremony of laying the foundation stone of the National Monument during George IV's visit to Edinburgh in 1822.

60
Glen Artney c.1822
Inscribed lower left : 'Lone Glen Artney's Hazel Shade / Lady of the Lake'.
Watercolour, 203 × 146
Wilton 1054
Private collection

In about 1822 Walter Fawkes, Turner's Yorkshire patron, commissioned Turner to make six drawings illustrating lines from poems by Scott, Byron and Moore. The next item also belongs to the same series. The Scott illustrations are discussed by Gerald Finley, *Landscapes of Memory*, p.75. The beautifully wooded Glen Artney in Perthshire was once partly a royal forest, and here in 1589 the Macgregors murdered James VI's forester, Drummond of Drummond Ernoch. Scott wove the episode into his *Legend of Montrose*. Glen Artney has been included in the place names on the map of the 1818 and 1822 tours, but this watercolour is possibly based on a drawing made on an earlier visit.

61
Melrose Abbey : Moonlight c.1822
Inscribed : 'If you would view fair Melrose aright / You must view it by the pale moonlight' (from Scott's *Lay of the Last Minstrel*)
Watercolour, 184 × 133
Wilton 1056
Private collection

See No.60.

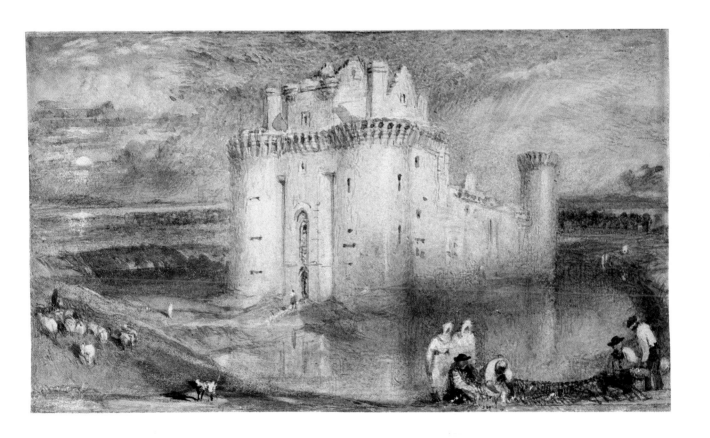

64 **Caerlaverock Castle** (*c*.1832)

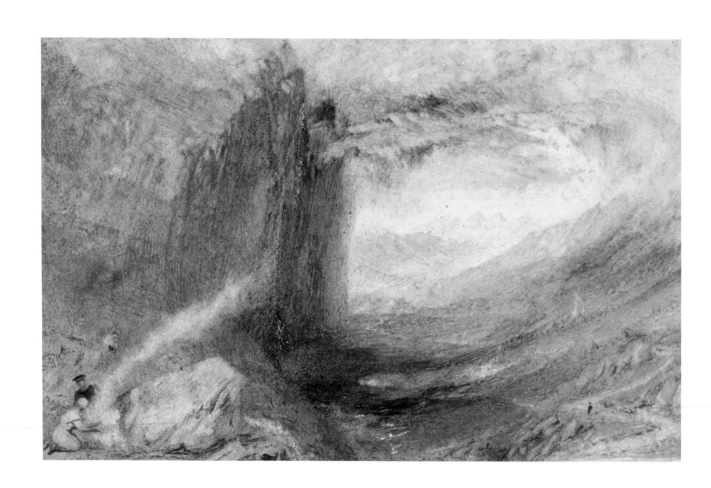

73 **Glencoe** (*c.*1833)

59

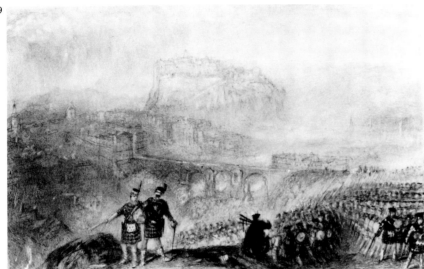

62
Robert Stevenson, *An Account of the Bell Rock Light-house; including the details of the Erection and Peculiar Structure of that Edifice*, Edinburgh 1824
Aberdeen University Library

The frontispiece is drawn by Turner, engraved by J. Horsburgh. The original watercolour is in a private collection. Turner did not himself visit the lighthouse but did it from sketches supplied by Andrew Masson in 1816 and by Macdonald in 1820. For a full discussion see John Gage, *Collected Correspondence of Turner*, p.287.

62

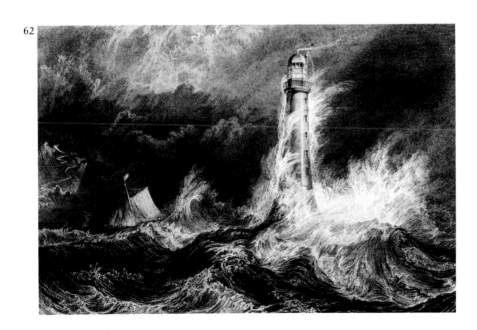

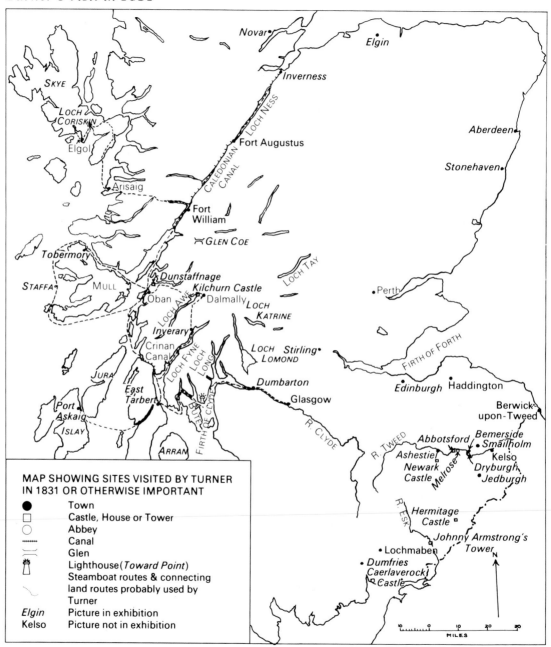

MAP SHOWING SITES VISITED BY TURNER
IN 1831 OR OTHERWISE IMPORTANT

● Town
□ Castle, House or Tower
○ Abbey
┉ Canal
 Glen
 Lighthouse (*Toward Point*)
 Steamboat routes & connecting
 land routes probably used by
 Turner
Elgin Picture in exhibition
Kelso Picture not in exhibition

[50]

The 1831 and 1834 Tours

63

Loch Awe with a Rainbow c.1831
(reproduced in colour opposite p.41)
Pencil and watercolour with some scraping
out, 224 × 285
Wilton 1144
Private collection

Turner exhibited a 'Kilchurn Castle' with a
rainbow (No.19) at the Royal Academy in
1802, but Andrew Wilton thinks that this
sheet is incompatible with such an early
date. Turner was in the vicinity of
Kilchurn again in 1831 (*Stirling and the
West* sketchbook CCLXX−18a). For related
studies see 'Scottish Pencils' TB LVIII, 13,
14, 15, 16.

64

Caerlaverock Castle c.1832
(reproduced in colour opposite p.48)
Watercolour, 83 × 140
Wilton 1076
Aberdeen Art Gallery and Museums

This watercolour is one of the twelve small
scenes painted by Turner from the
sketches he made on his 1831 Scottish
tour, to be engraved as frontispieces to the
edition of Scott's *Poetical Works* published
by Robert Cadell in 1834. 'Caerlaverock'
was used in the *Minstrelsy of the Scottish
Border* (see No.79). The jewel-like intensity
of Turner's colouring is well preserved.
After Cadell the watercolour was owned
by H.A.J. Munro of Novar. The
watercolour was acquired by Aberdeen
Art Gallery at auction in 1982 (Sotheby's,
London, 18 March).

65

Smailholm Tower c.1832
Watercolour, 191 × 140
Private collection

The figures in the carriage are Sir Walter
Scott, the publisher Cadell and Turner.
They are depicted returning from
Smailholm Tower after lunching at
Sandyknowe Farm, seen in the middle
distance. Turner shows himself sketching
the scene.

This drawing was done to commemorate
the visit and was sent abroad to Sir Walter
Scott as a gift which he received in Naples.

For related study see *Abbotsford*
sketchbook CCLXVII 83a. Another
version, without the carriage, was
engraved as the title-page vignette for J.G.
Lockhart, *Memoirs of the Life of Sir Walter
Scott*, 1839. The drawing also relates to the
title vignette for the *Poetical Works*, vol.I,
Minstrelsy of the Scottish Border.

There have been some repairs to the
upper part of the tower since Turner
painted it. The hills on either side are
further away in actual fact than Turner
has depicted them.

66

Abbotsford c.1832
Watercolour, 115 × 147, vignette
Wilton 1093
Private collection

One of the owners of this drawing after
Robert Cadell may have been John Ruskin.
It was engraved by H. Le Keux as the title-
page vignette to vol.XII, *Dramatic Pieces* in
the 1834 edition of Scott's *Poetical Works*.
There are related drawings in the
Abbotsford sketchbook
(TB CCLXVII).

The vignettes for the *Poetical Works*
were drawn with surrounds initially, but

these were left out of the printed versions
except in the case of *Abbotsford*. This is
drawn as if on a memorial wall plaque. To
the left is a view of Scott's armoury with
one of Scott's hounds, and to the right his
study, with the writer's empty chair.
G. Finley sees this as an intentional
memorial to Scott (*Landscapes of Memory*,
p.164). Finley has identified the
foreground figures as Turner and Cadell
returning to Abbotsford on the evening of
8 August 1831 after sketching in the area.

67

**Abbotsford from the North Bank of the
Tweed** c.1836
Watercolour, 89 × 139
Wilton 1142
Private collection

Drawn on either the 1831 or the 1834 tour.
It was engraved in 1839 by W. Miller as
the frontispiece to vol.VIII of Lockhart's
Life of Scott.

68

Newark Castle c.1832
Watercolour, 115 × 147
Wilton 1081
Private collection

The drawing was engraved by W.J. Cooke
in 1833, for Scott's *Poetical Works*, as the
title vignette to vol.VI, *Lay of the Last
Minstrel*. There is a related pencil drawing
in the *Abbotsford* sketchbook
(TB CCLXVII−78a).

Turner and Cadell visited Newark Castle
on Sunday, 7 August 1831. This vignette
was originally planned in a similar form to
Abbotsford (No.66). But the figures of
armoured knights to right and left, and the
suggestion of a memorial plaque, were left
out of the final engraving.

69
Dryburgh Abbey c.1832
Watercolour, 78 × 147
Wilton 1078
Tate Gallery, London

Engraved by W. Miller as the frontispiece
to vol.v, Scott's *Poetical Works* (No.80).
There are related studies in the *Abbotsford*
sketchbook (TB CCLXVII 8a–9). The
growth of trees since Turner painted this
view makes it impossible now to see
anything except the top of one of the
arches from this viewpoint.

70
Wolfe's Hope c.1835
Watercolour, 102 × 165
Wilton 1138
Private collection

Engraved by J. H. Kermot in 1836 for
Fisher's *Illustrations to the Waverley
Novels* 1836–7, *The Bride of Lammermoor*.
John Ruskin was the first owner of this
drawing.

71
'Stirling and the West' Sketchbook 1831
Inscribed inside cover: 'H A J Munro Esqr
/ Novar House, / Evanton N. B.'
Bound in green parchment, 91 leaves,
pencil, sketches on both sides, 202 × 124
Trustees of the British Museum (TB CCLXX)

Open at page 77a, showing successive
views of the Clyde coastline made from the
deck of a steam-boat. Turner may have
sailed from Glasgow round the Kyles of
Bute and up Loch Fyne to Inverary, on one
of the regular tours offered in the *Steam-
Boat Companion*. The views from top
downwards are 'Clyde S', 'Largs', 'Clyde
N'. The fourth view from the top
represents the Isle of Arran with Toward
lighthouse in the foreground. In fact Arran

71b

p.16 Stirling Castle

71d

p.92 Inversnaid, Loch Lomond

should be much more to the left and Turner appears to have arranged it to get a more effective relation between the lighthouse and the mountains behind.

The castles represented are, from top to lower edge of page, Toward Castle, Kaims Castle, and an old tower in ruins near Kaims. Turner has reversed the sketchbook and drawn a hurried view of Rob Roy's Caves on Loch Lomond side. This economy of paper is a feature of the *Stirling and the West* sketchbook. This sheet is an excellent example of Turner's working methods when on tour.

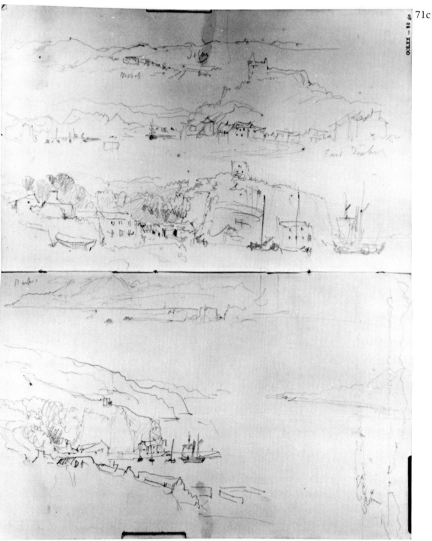

71a

p.77a

pp.79a–80, p.80 Islay, East Tarbert etc. *above*
p.79a Port Askaig (?) *below*

72

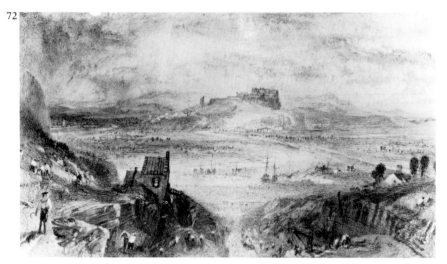

72
Stirling c.1833
Watercolour, 89 × 165
Wilton 1122
Glasgow Art Gallery and Museum

Engraved by W. Miller in 1836 for Scott's *Prose Works*, the frontispiece to vol.XXIII *Tales of a Grandfather*. There are several studies of Stirling Castle in the *Stirling and Edinburgh* sketchbook, (TB CCLXIX 47a–48, etc.). Munro of Novar was the first owner of this drawing.

73
Glencoe c.1833 or 1834
(reproduced in colour opposite p.49)
Watercolour, 94 × 143
Wilton 1126
Museum of Art, Rhode Island School of Design; Gift of Mrs Gustav Radeke 22.087

Engraved by W. Miller as the frontispiece to vol.XXV of Scott's *Prose Works, Tales of a Grandfather*. Munro of Novar was the first owner of this drawing.

Gerald Finley has analysed Turner's fresh approach to the Scottish landscape in these later watercolours which were painted to be engraved as frontispieces and title-page vignettes for the Cadell editions of Scott's *Prose* and *Poetical Works*. Emphasising the difference from the earlier landscape illustrations to Scott's *Provincial Antiquities of Scotland*, which were in the 'Picturesque' tradition, he writes of the illustrations to the *Poetical Works*: 'Turner consciously attempted to charge the landscape with a mood that was both authentic and consistent with that evoked in the "Poetry".'

74
Dunstaffnage c.1833
Watercolour and body colour, 121 × 152
Wilton 1124
Indianapolis Museum of Art; gift in memory of Dr and Mrs Hugo O. Pantzer

Engraved by W. Miller as the frontispiece to vol.XXIV of Scott's *Prose Works, Tales of a Grandfather*. There is a related study in the *Staffa* sketchbook (TB CCLXXIII-89).

75
Fingal's Cave, Staffa c.1832
Inscribed above: 'LORD of the Isles / Vol', and below: 'Fingals Cave'
Pencil and watercolour, 135 × 87
Wilton 1089
Private collection, USA

Engraved by E. Goodall for Scott's *Poetical Works*, the title vignette for volume X, *The Lord of the Isles*, see No. 84. After Robert Cadell, Munro of Novar was the next owner of this drawing, followed by John Ruskin. Turner's pencil sketches of Fingal's Cave are in the *Staffa* sketchbook, TB CCLXXIII, page 29 being used as the basis for the Scott vignette.

This vignette and the oil painting 'Staffa, Fingal's Cave' (Yale Center for British Art, which was unfortunately too fragile to be lent for this exhibition) commemorate Turner's trip to Staffa under adverse weather conditions: 'A strong wind and head sea . . . prevented us making Staffa until too late to go on to Iona.' Turner recalled: 'After scrambling over the rocks on the lee side of the island, some got into Fingals Cave, others would not. It is not very pleasant or safe when the wave rolls right in.'

When the canvas was shown at the Royal Academy in 1832 Turner quoted the following lines from Scott's *Lord of the*

Isles, Canto IV: '. . . nor of a theme less solemn tells / That mighty surge that ebbs and swells, / And still between each awful pause, / From the high vault an answer draws.'

Turner's development of a vortical composition in the vignettes illustrating Scott's *Poetical Works* has been pointed out by Adele M. Holcomb (*Art Quarterly*, XXXIII, 1970, pp.16–29): 'In his illustrations to Scott's poetry Turner transformed the vignette . . . from a vehicle for the compact symmetries of a neoclassical statement to a form peculiarly expressive of the energies of nature.' In connection with 'Fingal's Cave' Holcomb remarks upon 'the tension between crystalline form and the spiralling movement that passes through the faceted surfaces of the vignette.'

76
'Inverness' Sketchbook 1831
Bound in boards, with red leather back, forty-eight leaves, pencil, sketches on both sides, 165 × 101; bought from D. Morrison and Co., Booksellers, Stationers and Bookbinders, Inverness.
Trustees of the British Museum
(TB CCLXXVII)

When planning this exhibition it was known that Turner intended to visit Aberdeen on his 1831 tour, as he arranged to collect his mail there. It was not certain, however, whether he actually visited the city. New identifications of drawings in the *Inverness* sketchbook now leave no doubt that he did visit Aberdeen and the neighbourhood. An open crowned spire, drawn very roughly in a 'carriage sketch'—executed whilst passing—is almost certainly King's College Chapel, in Old Aberdeen, hitherto wrongly identified

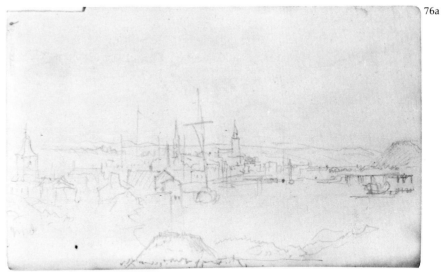

76a

p.6a Inverness

76c

p.55a Stonehaven and Dunnottar Castle

76b

p.42a King's College Chapel

76d

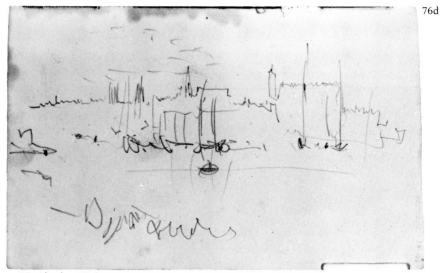

p.127a Aberdeen Harbour

76e

J.W. Allen 'Aberdeen Harbour', 1838

as that of St. Giles's Cathedral in Edinburgh. Although these two crown steeples are similar in design, King's has only four arched ribs to St. Giles's eight. For a full discussion see W. Douglas Simpson, *William Kelly. A Tribute Offered by the University of Aberdeen*, Aberdeen, 1949, Chapter II. Two hitherto unidentified harbours are definitely those of New Aberdeen, looking across the harbour mouth from the south bank, and Stonehaven (on page 55a) seen from the north, with Dunnottar Castle perched on the cliffs.

The sketchbook is open at page 127a, the view of Aberdeen harbour. It has been possible to identify this page by comparing it with contemporary engraved

views of the city, notably 'Aberdeen' by W.H. Bartlett and a view by J.W. Allen, dated 1838. The solid architectural mass to the right represents the old barracks. Turner's view was taken from Greyhope Road opposite the Pilot House, looking in a north-westerly direction.

77
Inverness c.1833
Watercolour, 92 × 159
Wilton 1128
Private collection

Engraved by W. Miller in 1836, for Scott's *Prose Works* 1834–6, the frontispiece to vol.xxvi, 1836, *Tales of a Grandfather*. There is a related study in the *Inverness* sketchbook on page 5 (No.76). Munro of Novar was the first owner of this drawing.

78–84
Sir Walter Scott, *The Poetical Works of Sir Walter Scott, Bart.*, 1834

The twelve volumes were published in Edinburgh by Robert Cadell. Seven volumes are being exhibited, all lent by the National Library of Scotland.

The nature of these later Scottish landscapes (in both the *Poetical* and the *Prose Works*) painted during the 1830s was determined by the fact that they were expressly intended to be engraved. Turner was commissioned to provide twenty-four designs at 25 guineas each for Cadell's edition of Scott's *Poetical Works*, in which each rectangular frontispiece confronts a title-page vignette.

Turner's treatment of these vignettes departs from the classical form of those he had done for Rogers's *Italy* (1830). Turner now frequently abandons a unified perspective and adopts, as Adele Holcomb

has argued, 'a movemented interplay of complex spatial elements . . . opening up . . . the vignette to a new interaction with the page' (*Art Quarterly*, XXXIII, 1970, p.16).

Turner stayed at Abbotsford for part of his tour of Scotland in 1831 and made day excursions to significant sites and monuments in the company of Scott himself and Robert Cadell. 'Melrose' (No. 81) is an example of this stage of his tour. Once Turner had set out on his exploration of the Highlands and Islands making use of the recently established steamer services, he designed his most successful vortical compositions sparked off by visiting Fingal's Cave, and Loch Coriskein on Skye (Nos.75 and 84).

Cadell's next project was for an edition of the collected non-fictional *Prose Works* and for a special edition of the *Waverly Novels*. Turner was originally to have been involved in both schemes, but in the end he prepared forty designs for the *Prose Works* only, in addition to some plates for J.G. Lockhart's *Life of Sir Walter Scott*.

In the autumn of 1832 Turner was in France collecting material for Scott's *Life of Napoleon* with which the series was to be launched. In the late summer of 1834 he was again in Edinburgh where he sketched Scott's residence in Castle Street (No.92), and other significant locations associated with the writer and with the *Waverley Novels*, as well as making excursions to Lanark, Melrose, Selkirk and elsewhere.

Of the illustrations for the *Prose Works* (Nos.85–90), we have been especially fortunate in being generously lent two fine examples from the USA: 'Dunstaffnage' (No.74) by the Indianapolis Museum of Art and 'Glencoe' (No.73) by the Rhode Island School of Design. 'Inverness' (No.77) has been kindly lent by a private owner in the UK. For the *Poetical Works* Aberdeen Art Gallery's own 'Caerlaverock

Castle' (No.64), has been joined by 'Fingal's Cave' (No.75) most kindly lent by a private owner in the USA, 'Dryburgh Abbey' (No.69) from the Tate Gallery, and 'Abbotsford' and 'Newark Castle' (Nos.66 and 68), generously loaned by a private owner in the UK. These original watercolours have been supplemented by framed engravings and printed books.

78
Vol.II
Frontispiece: 'Jedburgh Abbey' (*Minstrelsy of the Scottish Border*), engraved by R. Brandard
144 × 86, subject
Rawlinson 495
The drawing is in the Taft Museum, Cincinnati

Title-page vignette: 'Johnnie Armstrong's Tower' (*Minstrelsy of the Scottish Border*), engraved by E. Goodall
83 × 102, subject
Rawlinson 496
The drawing is in the Taft Museum, Cincinnati

79
Vol.IV
Frontispiece: 'Caerlaverock Castle' (*Minstrelsy of the Scottish Border*), engraved by E. Goodall
143 × 83, subject
Rawlinson 499
The watercolour is in the collection of Aberdeen Art Gallery (No.64)

Title-page vignette: 'Hermitage Castle' (*Minstrelsy of the Scottish Border*), engraved by R. Wallis
85 × 105, subject
Rawlinson 500
The drawing is in a private collection

78b

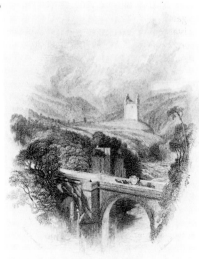

80b

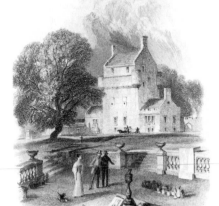

80
Vol.v
Frontispiece: 'Dryburgh Abbey' (*Sir Tristrem*), engraved by W. Miller
148 × 78, subject
Rawlinson 501
See also No.69

Title-page vignette: 'Bemerside Tower' (*Sir Tristrem*), engraved by J. Horsburgh
118 × 90, subject
Rawlinson 502

81
Vol.vi
Frontispiece: 'Melrose' (*Lay of the Last Minstrel*), engraved by W. Miller
137 × 87, subject
Rawlinson 503
The drawing is in the National Gallery of Scotland (Vaughan Bequest)

Title-page vignette: 'Newark Castle' (*Lay of the Last Minstrel*), engraved by W.J. Cooke
85 × 103, subject
Rawlinson 504
The drawing is in a private collection (No.68)

82
Vol.vii
Frontispiece: 'Edinburgh from Blackford Hill' (*Marmion*), engraved by J. Horsburgh
146 × 85, subject
Rawlinson 505
The drawing is in the collection of the Earl of Rosebery

Title-page vignette: 'Ashestiel' (*Marmion*), engraved by J. Horsburgh
84 × 102, subject
Rawlinson 506
The drawing is in the Fitzwilliam Museum, Cambridge

83
Vol.viii
Frontispiece: 'Loch Katrine' (*Lady of the Lake*), engraved by W. Miller
137 × 87, subject
Rawlinson 507
The drawing is in the British Museum (Lloyd Collection)

Title-page vignette: 'Loch Achray' (*Lady of the Lake*), engraved by W. Miller
83 × 89, subject
Rawlinson 508
The drawing is in the Yale Center for British Art, Paul Mellon Collection

84
Vol.x
Frontispiece: 'Loch Coriskin' (*Lord of the Isles*), engraved by H. Le Keux
130 × 81, subject
Rawlinson 511
The drawing is in the National Gallery of Scotland (Vaughan Bequest)

Title-page vignette: 'Fingal's Cave, Staffa' (*Lord of the Isles*), engraved by R. Goodall
130 × 121, subject
Rawlinson 512
The drawing is in a private collection (No.75)

85–90
Sir Walter Scott, *The Miscellaneous Prose Works*, 1834–36

The twenty-eight volumes were published in Edinburgh by Robert Cadell, from which six framed prints are being exhibited here, all lent by the National Gallery of Scotland.

Of the forty illustrations that Turner produced for the *Prose Works*, fourteen are of Scottish scenes, the majority being for *Tales of a Grandfather*.

83a

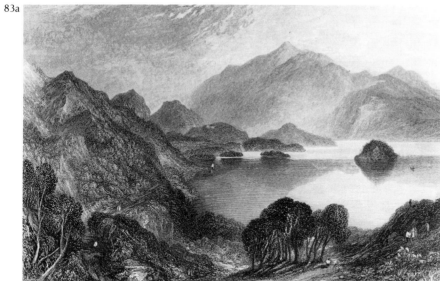

84a

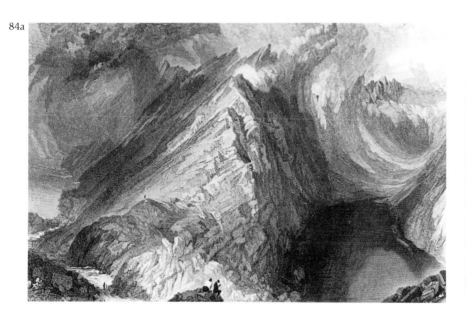

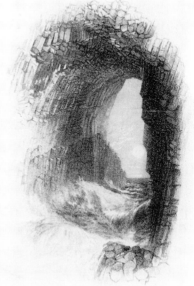

85
Dumbarton Castle
Engraving, 89 × 80
Rawlinson 518
Vignette in the *Biographical Memoirs*,
engraved by W. Miller
Munro of Novar owned the original
drawing

86
Rhymer's Glen, Abbotsford
Engraving, 78 × 121
Rawlinson 542
Vignette in *Periodical Criticism*, engraved
by W. Miller
The original drawing is in the Vaughan
Bequest, National Gallery of Scotland

87
Linlithgow
Engraving, 84 × 84
Rawlinson 548
Vignette in *Tales of a Grandfather*,
engraved by W. Miller

88
Glencoe
Engraving, 143 × 87
Rawlinson 549
Frontispiece in *Tales of a Grandfather*,
engraved by W. Miller
(See also No.73)

89
Killiecrankie
Engraving, 80 × 102
Rawlinson 550
Vignette in *Tales of a Grandfather*,
engraved by W. Miller

90
Inverness
Engraving, 137 × 79
Rawlinson 551
Frontispiece in *Tales of a Grandfather*,
engraved by W. Miller
Munro of Novar owned the original
drawing (See also No.77)

91–92
J.G. Lockhart, *Memoirs of the Life of Sir
Walter Scott*, 1839

Of the eight volumes, two volumes have
been lent by the National Library of
Scotland. Vol.VIII contains a view of
'Abbotsford from the Northern Bank of
the Tweed' as its frontispiece by Turner.
Only these three volumes contain Turner
designs.

91
Vol.II
Title-page vignette: 'Smailholm Tower and
Sandyknowe Farm', engraved by
W. Miller
104 × 89

92
Vol.IV
Title-page vignette: 'Scott's Birthplace, 39
Castle Street, Edinburgh', engraved by
W. Miller
112 × 86
The original drawing for this vignette is in
the Pierpont Morgan Library, New York.

Ephemera and additional books

Handbill advertising 'Pleasure Excursion' on 'The Leven' Steampacket
Museum of Transport, Glasgow

99

Advertisement for 'Regular Conveyance' from Glasgow to Inverary and Arran
Museum of Transport, Glasgow

100–103

H.A.J. Munro of Novar

Hugh Andrew Johnstone Munro of Novar (?-1865) was one of Turner's principal patrons and a close personal friend. They were on familiar terms by 1826 (see J. Gage, *Collected Correspondence of Turner*, No.119). H.A.J. Munro owned an extensive collection of both Old Masters and modern British painters, divided between his London residence at 113 Grosvenor Square and his Scottish seat of Novar, Evanton, north of Inverness.

He had inherited a Murillo from his father and owned three Titians and works by Rubens, Velasquez, Van Dyck, Gaspard Poussin, and a number of works by Dutch seventeenth-century masters including Jan Steen, Cuyp and Jacob Ruisdael. In addition he owned some French eighteenth-century works by Watteau, Greuze and Boucher. His British pictures included paintings by Reynolds, Gainsborough, Hogarth and Richard Wilson. To these was added his collection by contemporary artists which embraced Blake, Bonington, Etty, Maclise, Constable, Thomas Stothard and Wilkie.

Amongst his oil paintings by Turner was 'The Wreck Buoy' (Walker Art Gallery, Liverpool), which Turner had particularly wished to enter Munro's collection. (For a full discussion see M. Butlin and E. Joll, *Paintings of Turner*, No.428.) Munro also owned 'Snowstorm, Avalanche and Innundation – a scene in the Upper Part of Val d'Aouste' (Art Institute of Chicago). This canvas was the outcome of Turner's trip to the Val d'Aosta in 1836 in Munro's company (Butlin and Joll, No.371). In 1833 Munro had financed a trip to Venice and the resulting painting 'Venice from the Porch of Madonna della Salute' (Metropolitan Museum, New York), also joined Munro's collection (Butlin and Joll, No.362).

Munro owned some 130 watercolours by Turner, including most of the original watercolours done for Scott's *Poetical Works*. Regrettably, Munro had no legitimate heir, and his collection was dispersed in sales held at Christie's (11 May 1867, 18 May 1867, 2 June 1877, 6 April 1878).

During the trip they took together in 1836 to the Val d'Aosta, Turner and Munro, who was an amateur artist, sketched in each other's company. On one occasion Turner seems to have given Munro a lesson in watercolour painting when they were sketching near Salenche (manuscript note in H.A.J. Munro's copy of Thornbury's *Turner*, 1862, vol.I, p.280, in the collection of Professor Francis Haskell). Unfortunately no known examples of Munro's work survives. Ruskin provides an interesting account of a drawing lesson by Turner: 'One of the points in Turner which increased the general falseness of the impression respecting him was a curious dislike he had to *appear* kind. Drawing, with one of his best friends [Munro of Novar], at the bridge of St Martin's, the friend got into great difficulty over a coloured sketch. Turner looked over him a little while, and then said, in a grumbling way, "I haven't

93

Palette and spectacles belonging to Turner
Visitors of the Ashmolean Museum, Oxford

This white ceramic palette, bearing traces of watercolour in reds, blues and greens, together with the two pairs of spectacles, were collected by Ruskin. One of the two identical palette knives, bears the manufacturer's name, 'W. Wilbon'.

94

Taylor and Skinner, *Survey and Maps of the Roads of North Britain or Scotland*, London, 1776
Aberdeen University Library

95

Lumsden & Son, *Steam-Boat Companion; or Stranger's Guide to the Western Isles & Highlands of Scotland*, third edition, Glasgow 1831
Mitchell Library, Glasgow

96

Metal cabin token
Museum of Transport, Glasgow

97

Passage ticket to Rothesay
Museum of Transport, Glasgow

got any paper I like, let me try yours''. Receiving a block book, he disappeared for an hour and a half. Returning, he threw the book down, with a growl, saying, ''I can't make anything of your paper''. There were three sketches on it, in three distinct states of progress, showing the process of colouring from beginning to end, and clearing up every difficulty which his friend had got into.' (Ruskin, *Works*, VII, p.446, note.)

In 1831 Turner visited Novar which was the northernmost point of his Scottish tours. No sketches of the immediate vicinity have been identified, but Turner used the view of the Cromarty Firth from Novar as the background to a picture of 'Mercury and Argus' (National Gallery of Canada, Ottawa), which was shown at the Royal Academy in 1836 (Butlin and Joll, No.367).

Munro purchased a number of Turner's Swiss watercolours in the early 1840s, including Aberdeen Art Gallery's 'Bellinzona from the Road to Locarno' (No.104).

H.A.J. Munro of Novar remains a shadowy figure apart from his tastes as a collector. He was apparently a shy individual as a younger man, as Turner refers to him in 1826 as having 'lost a great deal of that hesitation in manner and speech' (J. Gage, *Collected Correspondence*, No.119).

100
J.M.W. Turner
Manuscript letter from the artist to Edward Francis Finden 1831
Photographs
Boston Public Library, Boston, USA

This letter provides invaluable evidence for Turner's visit to Novar, together with his intention of returning south by way of Aberdeen. As J. Gage has pointed out (*Collected Correspondence*, p.145), Turner has confused the Linn of Dee and the Brig of Don, both associated with Byron's childhood. In the event none of the illustrations to Moore's *Life and Letters of Lord Byron* include Aberdeen views.

101
J.R. Smith
Portrait of Hugh Andrew Johnstone Munro of Novar c.1810
Pastel, 241 × 202
Arthur Munro Ferguson

102
Mrs Robert Munro Ferguson
Novar House and Garden c.1880
Three watercolours, each 213 × 304
Arthur Munro Ferguson

Although executed fifty years after Turner's visit, the house had not been altered since 1831.

103
J.M.W. Turner
Bellinzona, from the Road to Locarno 1843
Watercolour with scraping out, 293 × 456
Wilton 1539
Aberdeen Art Gallery and Museums

There is a study for this picture in the Turner Bequest (TB CCCXXXII-25) which is inscribed on the back: 'Bellinzona No 12' and 'Mr Munro'.

Select Bibliography

Butlin, Martin and Joll, Evelyn, *The Paintings of J.M.W. Turner*, 2 vols, New Haven and London, 1977

Farington, Joseph, *Diary*, vol.v, August 1801–March 1803, ed. Kenneth Garlick and Angus Macintyre, New Haven and London, 1979

Finberg, Alexander J., *The Life of J.M.W. Turner, R.A.*, second edition revised by Hilda F. Finberg, Oxford, 1961

Finberg, Alexander J., *The History of Turner's Liber Studiorum with a New Catalogue Raisonné*, London, 1924

Finberg, Alexander J., *Complete Inventory of the Drawings of the Turner Bequest*, 2 vols, London, 1909

Finley, Gerald, *Landscapes of Memory. Turner as Illustrator to Scott*, London, 1980

Finley, Gerald, *Turner and George IV in Edinburgh, 1822*, London and Edinburgh, 1981

Finley, Gerald, 'Turner and Sir Walter Scott: Iconography of a Tour', in *Journal of the Warburg and Courtauld Institutes*, xxxv, 1972, pp.359–85

Frost, W., revised by Reeve, Henry, *A complete Catalogue of the Paintings, Water-Colour Drawings and Prints in the Collection of the late Hugh Andrew Johnstone Munro of Novar at the time of his death deposited in his house No.6 Hamilton Place, London, with some additional Paintings at Novar*, London, 1865

Gage, John, *Colour in Turner. Poetry and Truth*, London, 1969

Gage, John, *Collected Correspondence of J.M.W. Turner, with an Early Diary and a Memoir by George Jones*, Oxford, 1980

Greater London Council, *Turner and the Poets*, London, 1975. Exhibition catalogue by Mordechai Omer

Hamerton, Philip Gilbert, *The Life of J.M.W. Turner, R.A.*, London, 1879

Herrmann, Luke, *Ruskin and Turner. A Study of Ruskin as a Collector of Turner*, London, 1968

Holcomb, Adele M., 'The Vignette and the Vortical Composition in Turner's Oeuvre', in *Art Quarterly*, xxxiii, Spring 1970, pp.16–29

Holcomb, Adele M., 'Turner and Scott', *Journal of the Warburg and Courtauld Institutes*, xxxiv, 1971, pp.386–97; revised as 'Scott and Turner', in *Scott Bicentenary Essays*, ed. A.S. Bell, Edinburgh and London, 1973, pp.199–212

Rawlinson, W.G., *The Engraved Work of J.M.W. Turner, R.A.*, 2 vols, London, 1908–13

Ruskin, John, *Modern Painters*, 5 vols, 1843–60; reprinted in Library Edition ed. E.T. Cook and Alexander Wedderburn, vols.iii–vii, London, 1903–5

Russell, John and Wilton, Andrew, *Turner in Switzerland*, Zurich, 1976

Tate Gallery and Royal Academy of Arts, *Turner 1775–1851*, London, 1974–5. Exhibition catalogue by Martin Butlin, Andrew Wilton and John Gage

Thornbury, Walter, *The Life of J.M.W. Turner, R.A.*, 2 vols, London, 1862

Wilkinson, Gerald, *Turner's Early Sketchbooks. Drawings in England, Wales and Scotland from 1789 to 1802*, London, 1972

Wilkinson, Gerald, *The Sketches of Turner, R.A. 1802–20: Genius of the Romantic*, London, 1974

Wilkinson, Gerald, *Turner's Colour Sketches 1820–34*, London, 1975

Wilton, Andrew, *The Life and Work of J.M.W. Turner*, London, 1979

Wilton, Andrew, *Turner and the Sublime*, London, 1980

Wilton, Andrew, *Turner in the British Museum, Drawings and Watercolours*, London, 1975